# COLORING BOOK

President and Publisher
**MIKE RICHARDSON**

Editor
**MEGAN WALKER**

Designer
**SARAH TERRY**

Digital Art Technician
**SAMANTHA HUMMER**

Special thanks to Corinne Combs, Kristin Conte, Kurt Estes, Megan Startz, Michael Sund,
and Susan Weber at NBCUniversal, and Joshua Engledow at Dark Horse Comics.

**JURASSIC WORLD™ : FALLEN KINGDOM COLORING BOOK**

Published by Dark Horse Books
A division of Dark Horse Comics LLC
10956 SE Main Street, Milwaukie, OR 97222

DarkHorse.com
: Facebook.com/DarkHorseComics
: Twitter.com/DarkHorseComics

To find a comics shop in your area, visit comicshoplocator.com.

First edition: April 2019 | ISBN 978-1-50670-975-8

1 3 5 7 9 10 8 6 4 2
Printed in the United States of America

# COLORING BOOK

With Illustrations by

**CRIS BOLSON**

**MARC BORSTEL**

**EDUARDO FRANCISCO**

**ÁLVARO SARRASECA**

DARK HORSE BOOKS

"RELAX. ANYTHING IN HERE'D BE DEAD BY NOW."
—SUBMARINE DRIVER

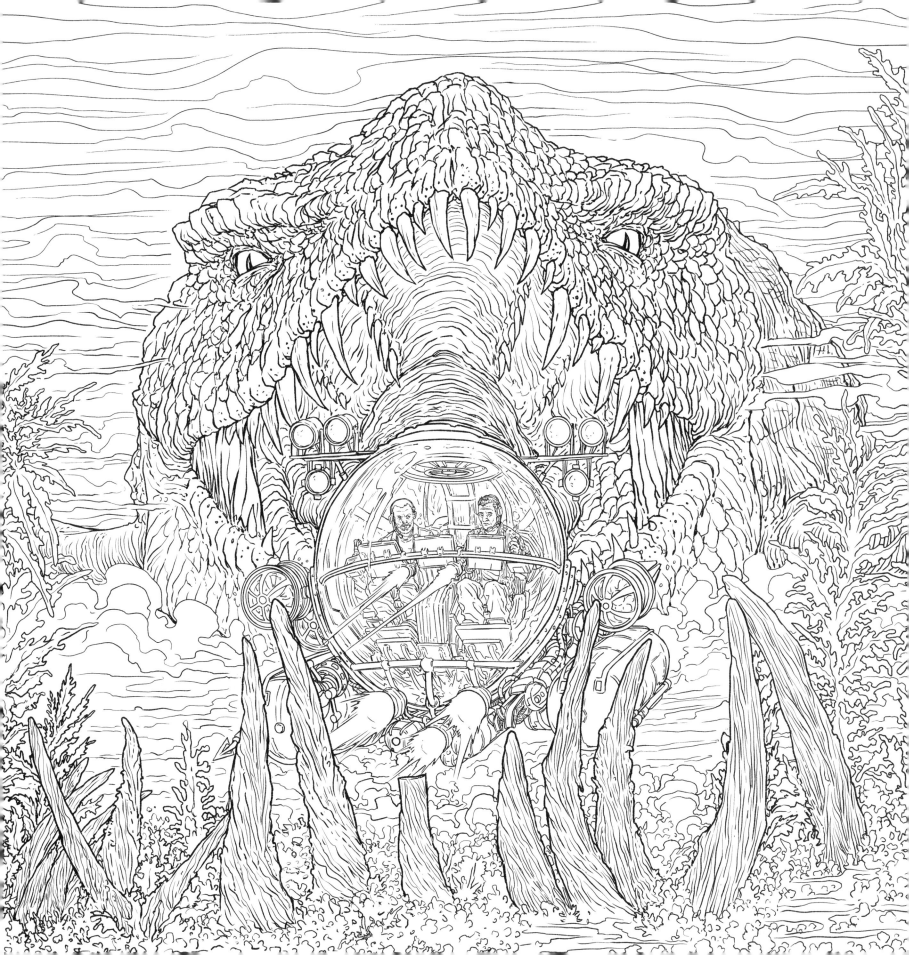

"SERIOUSLY, GUYS, I'M KINDA EXPOSED OUT HERE."

—TECHNICIAN

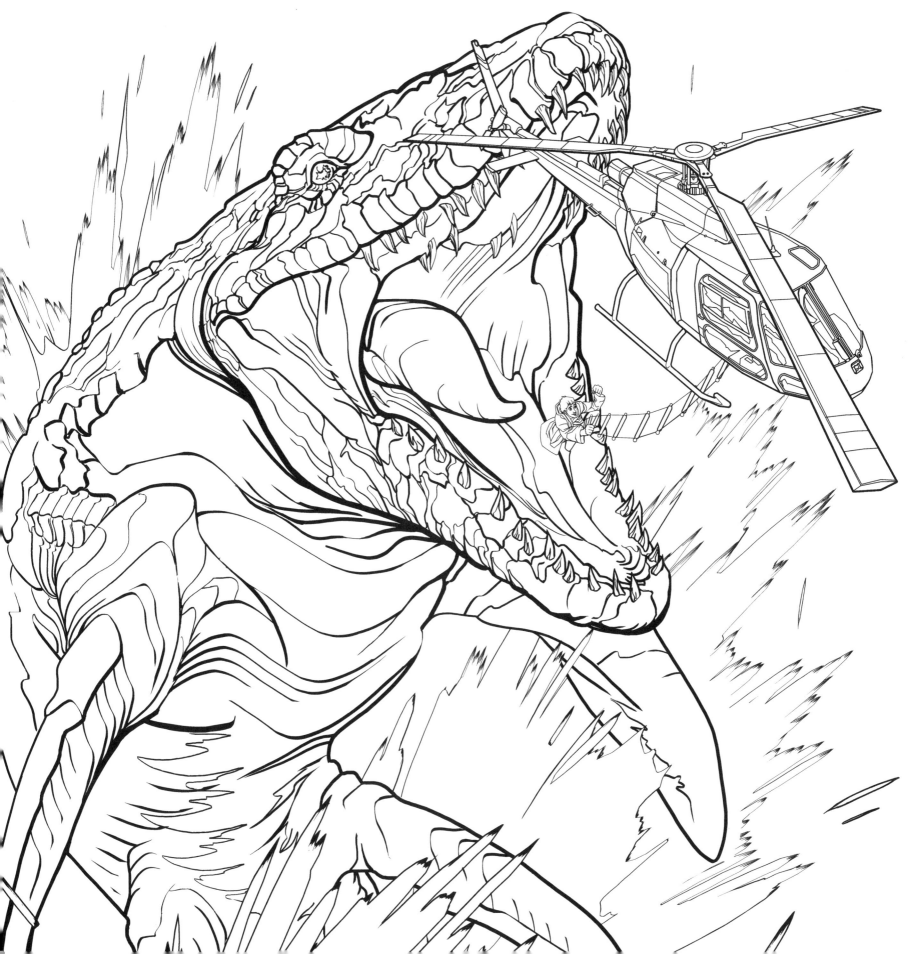

"I THINK THAT WE SHOULD ALLOW OUR MAGNIFICENT, GLORIOUS DINOSAURS TO BE TAKEN OUT BY THE VOLCANO."

-DR. IAN MALCOLM

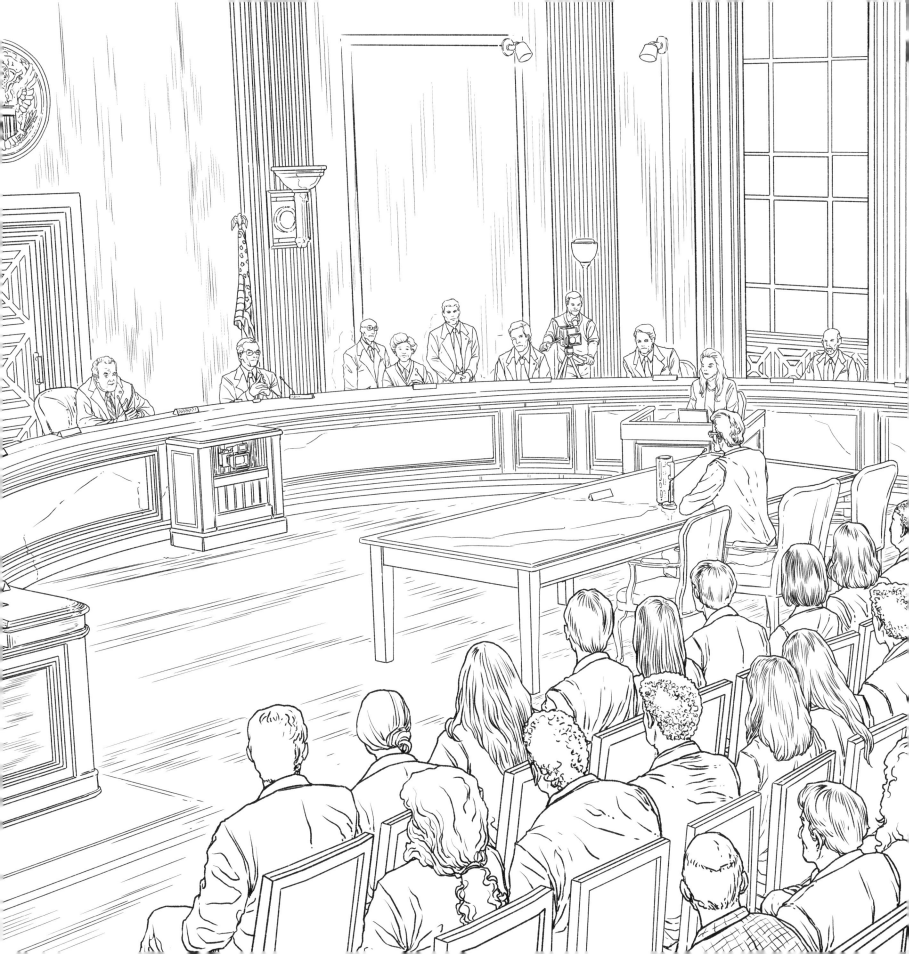

"THEY'RE ALL GOING TO DIE AND NO ONE CARES."

-CLAIRE

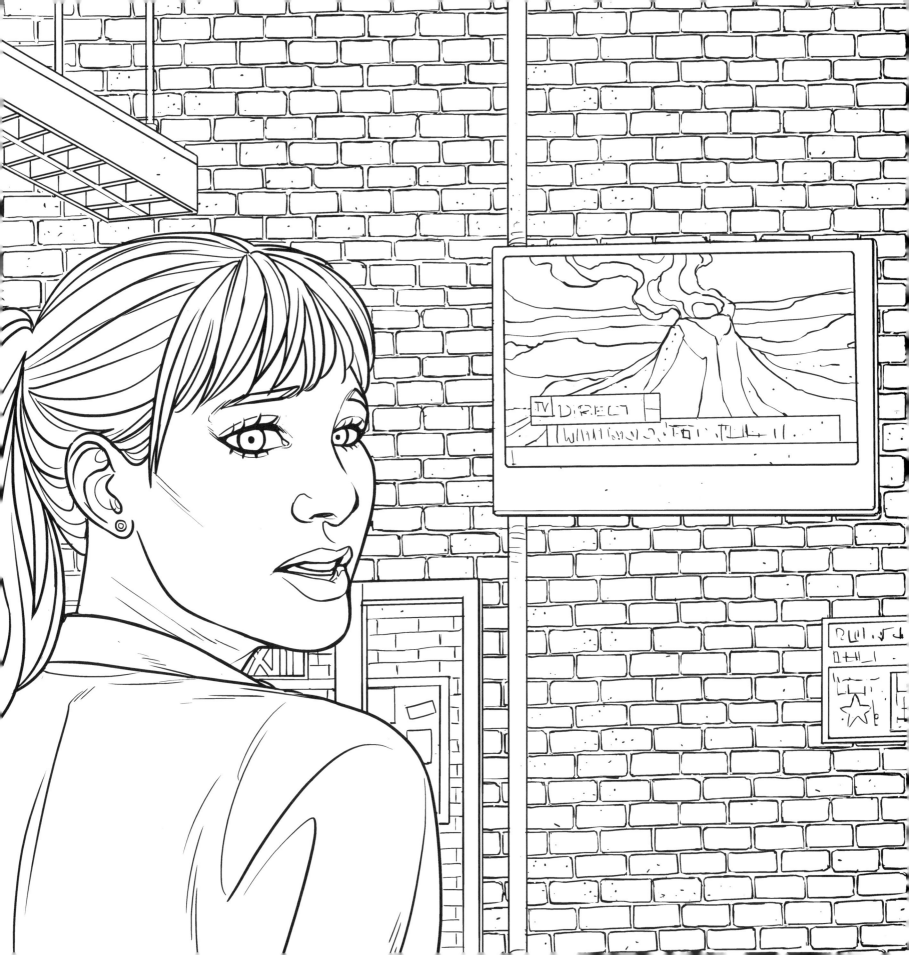

"WE HAVE A PIECE OF LAND, A SANCTUARY PROTECTED BY NATURAL BARRIERS, FULLY SELF-SUSTAINING. A NEW HOME WHERE THE DINOSAURS WILL BE SECURE AND FREE."

"YOU'RE GOING TO SAVE THEM?"

-ELI AND CLAIRE

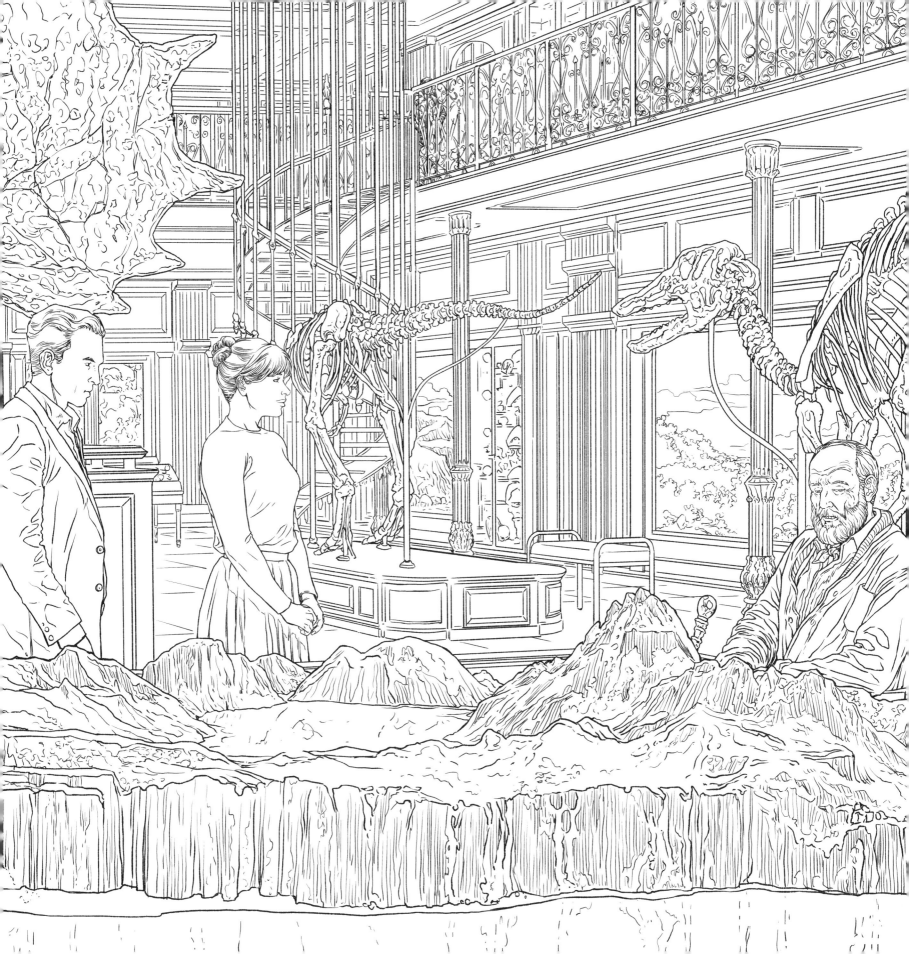

"BACK FOR MORE, HUH?"

-OWEN

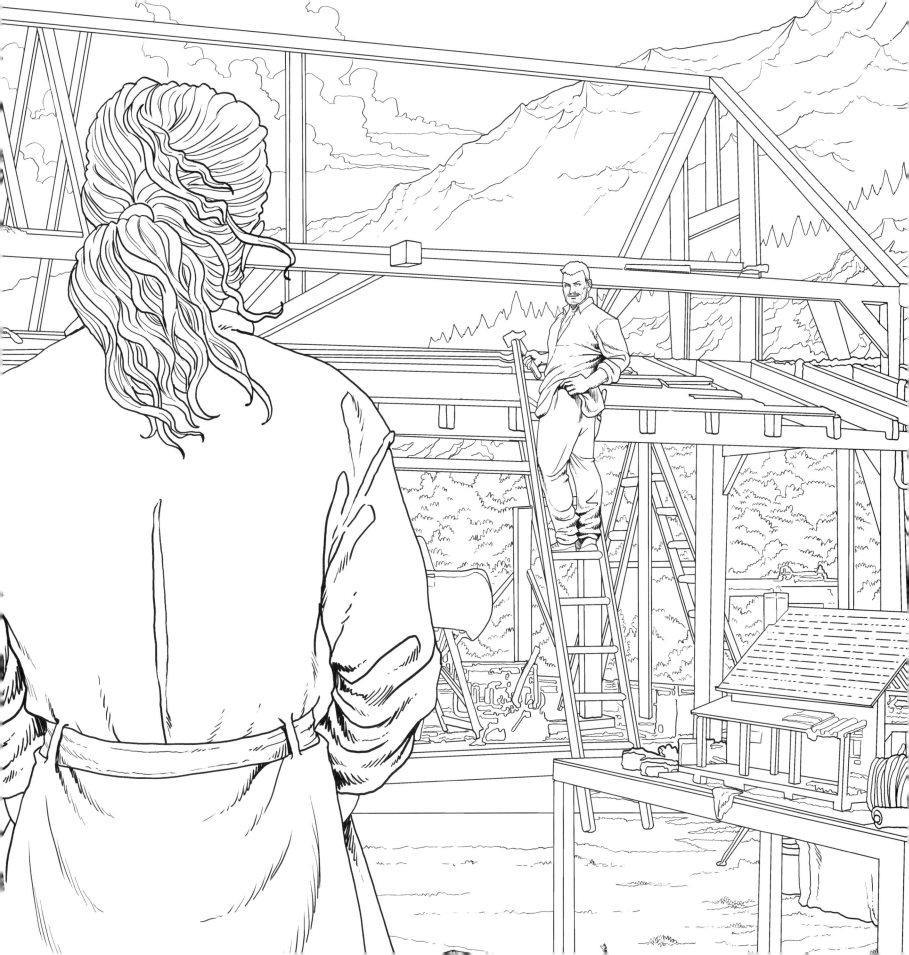

"BLUE IS ALIVE. YOU RAISED HER, OWEN. YOU
SPENT YEARS OF YOUR LIFE WORKING WITH HER.
YOU'RE JUST GOING TO LET HER DIE?"

-CLAIRE

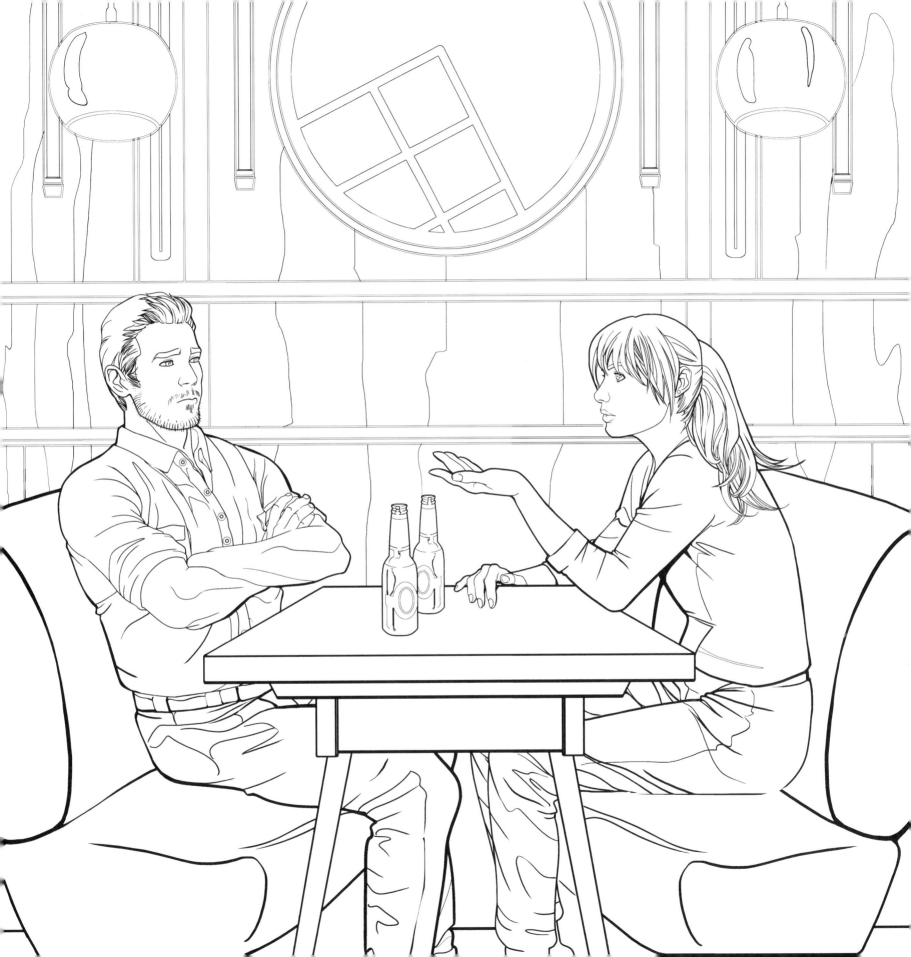

"I'M THE EXPEDITION FACILITATOR."

-WHEATLEY

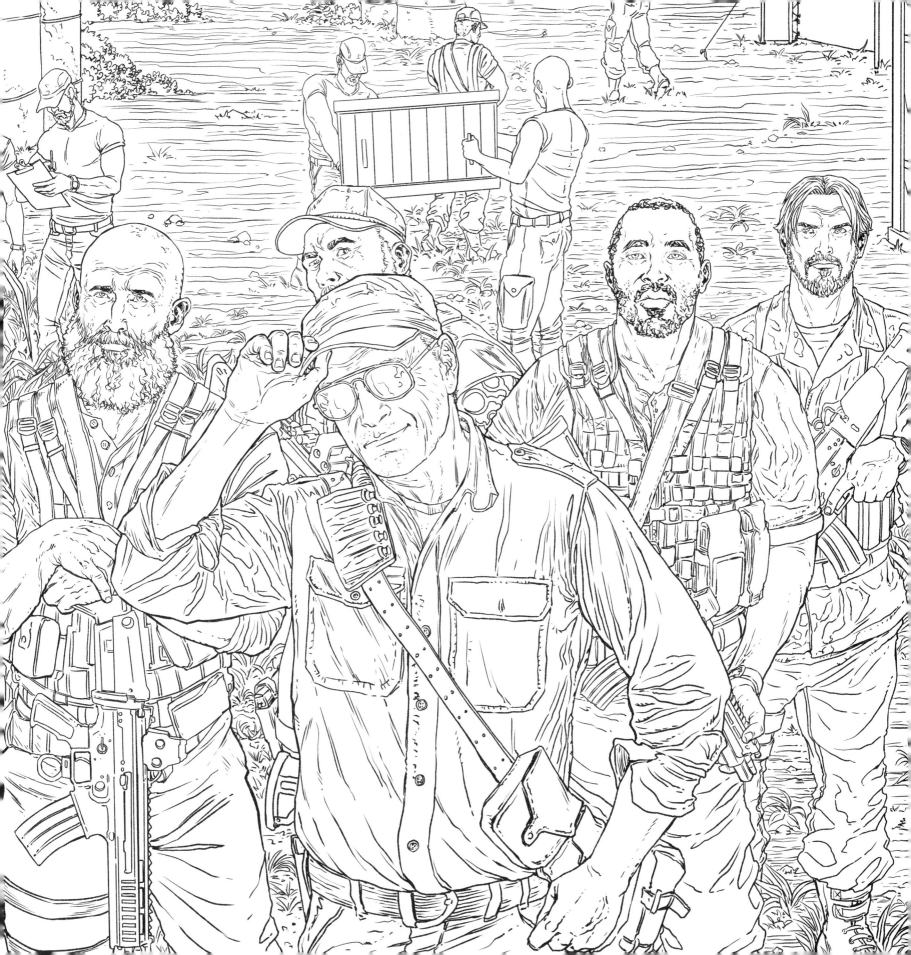

"SO, THE *T. REX* WOULD BE DEAD BY NOW, RIGHT?"

-FRANKLIN

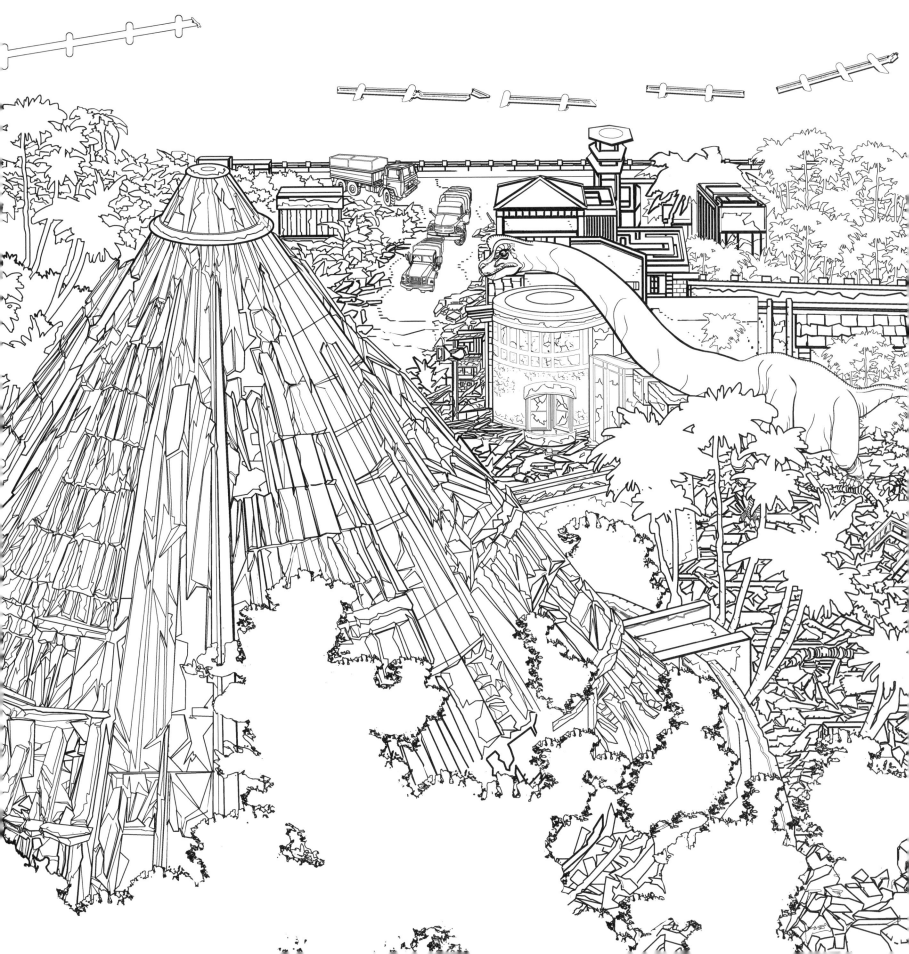

"LOOK AT THAT! NEVER THOUGHT I'D SEE ONE IN REAL LIFE."

-ZIA

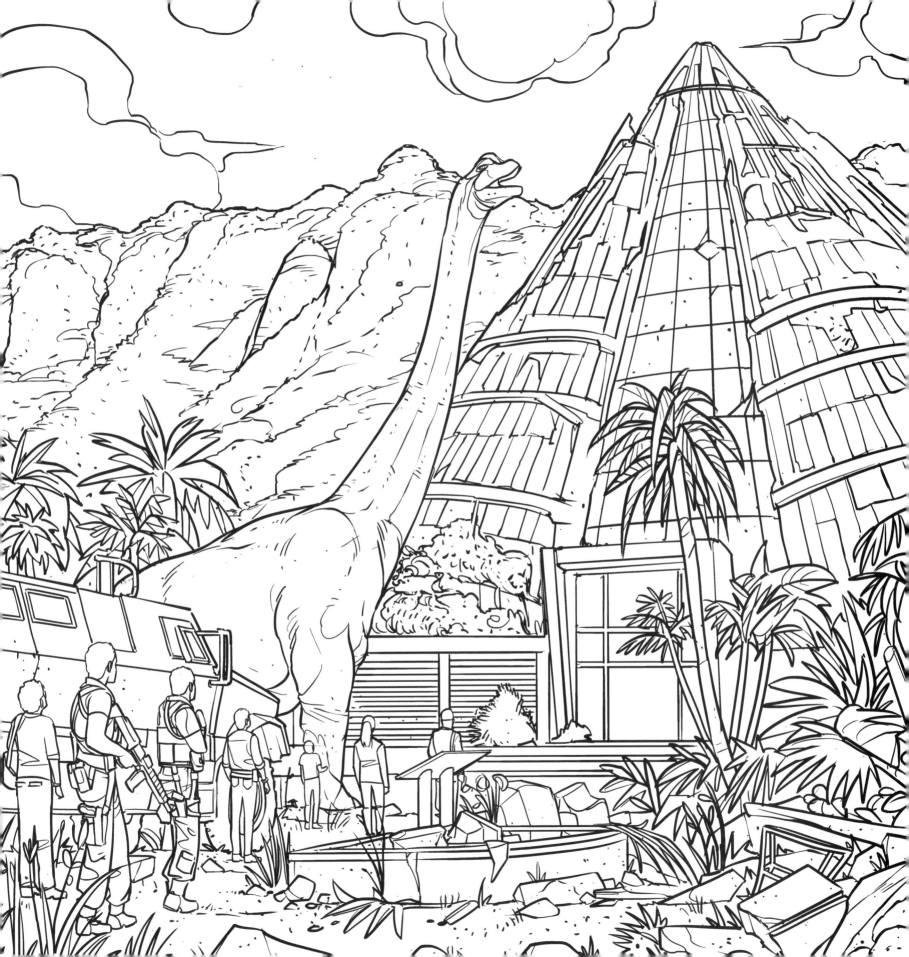

"THERE SHE IS."

-OWEN

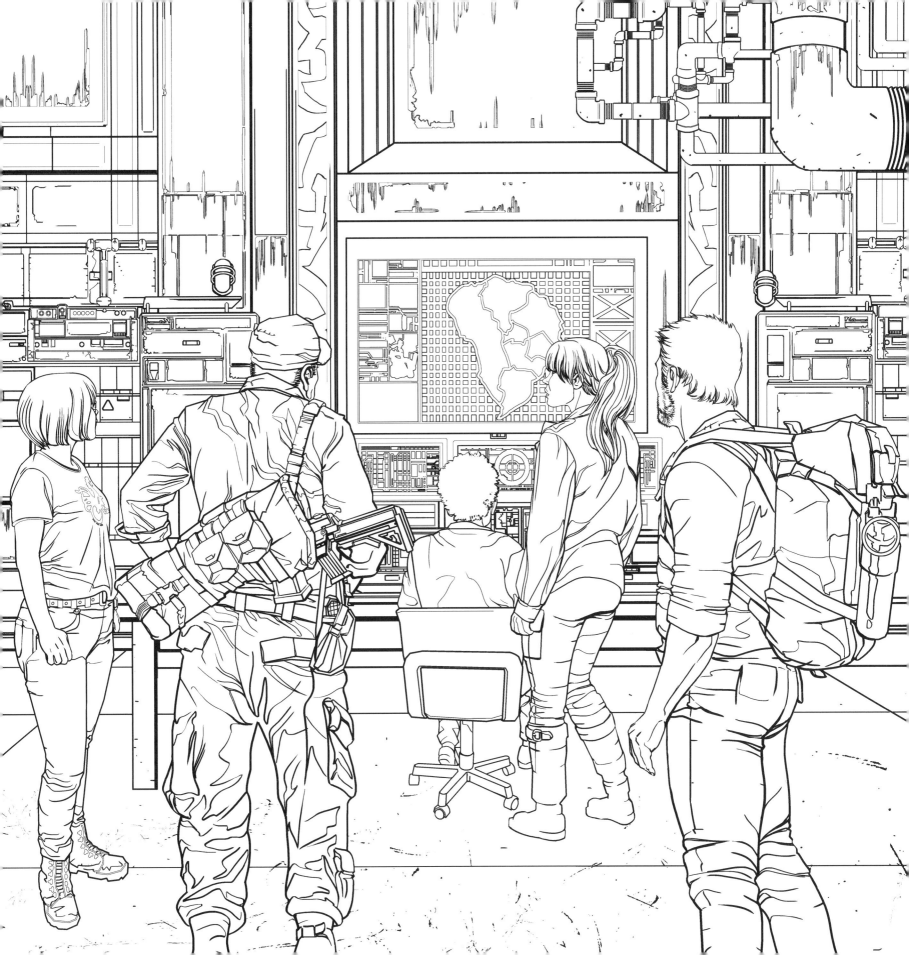

"HEY GIRL. YOU MISS ME?"

—OWEN

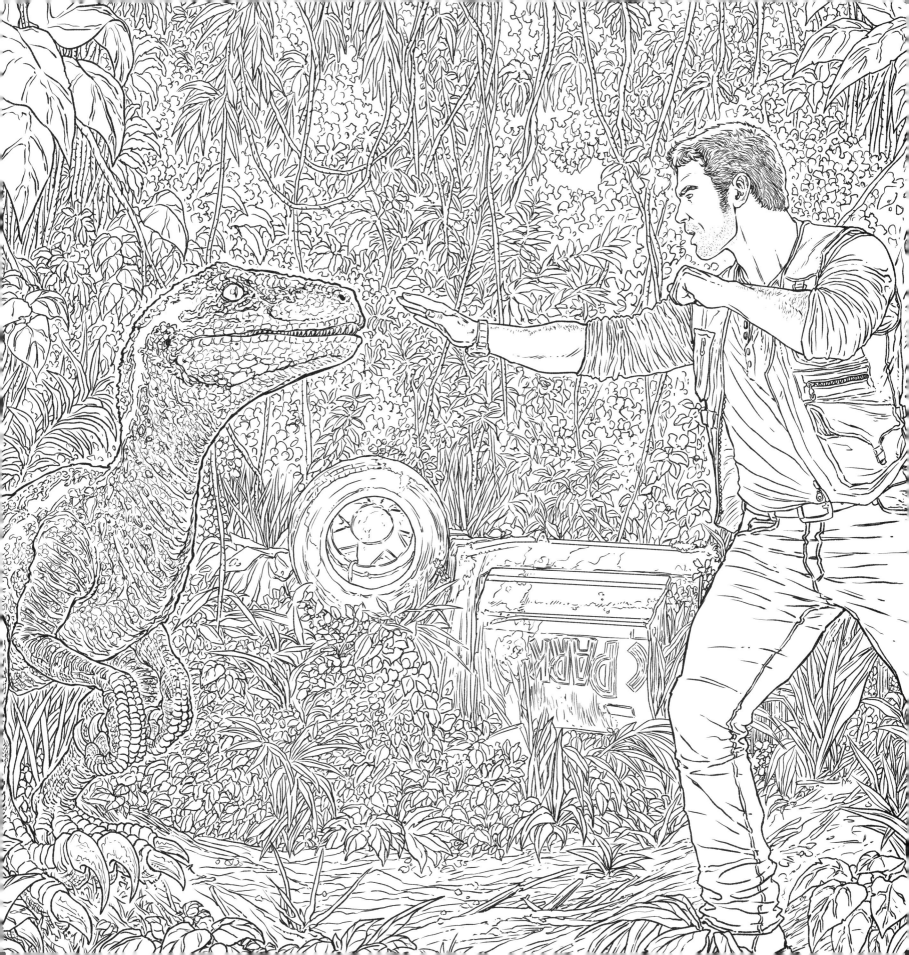

"I TOLD YOU TO WAIT FOR MY SIGNAL!"

-OWEN

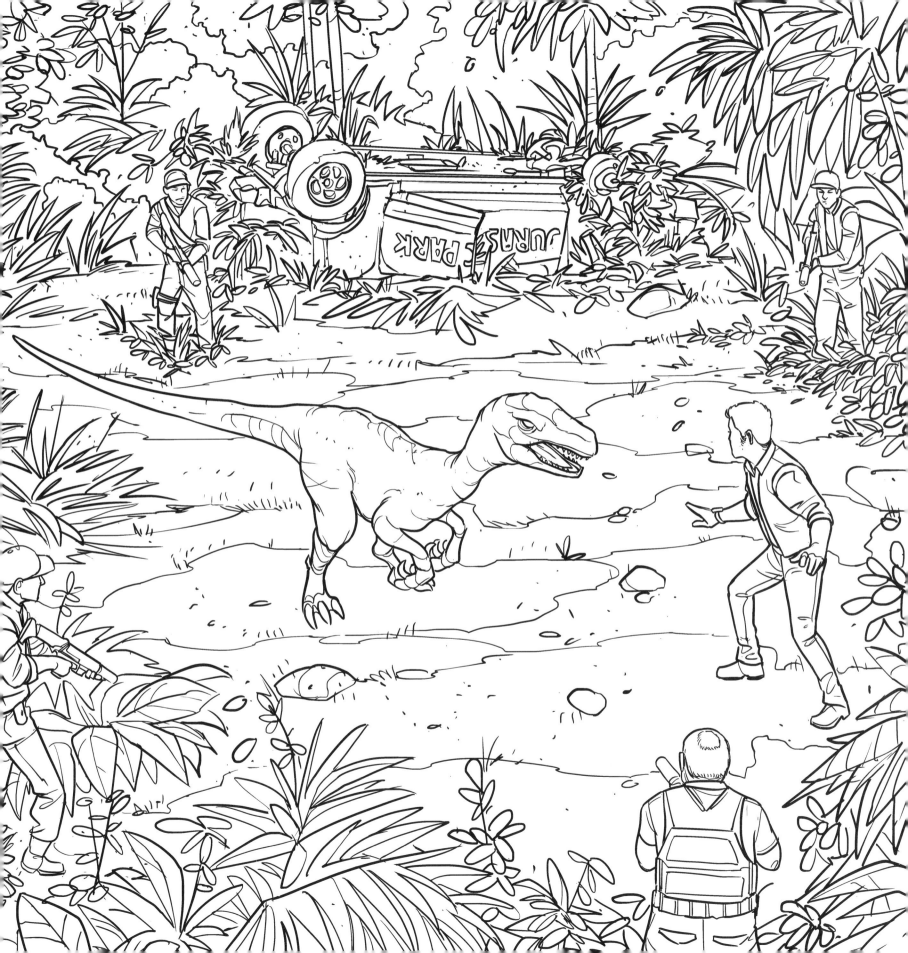

"HEY MILLS, WE GOT HER DONE. MISSION ACCOMPLISHED. HA HA HA. JUST IN THE NICK OF TIME!"

"WHEATLEY. YOU GET THOSE ANIMALS HERE NOW!"

-WHEATLEY AND ELI

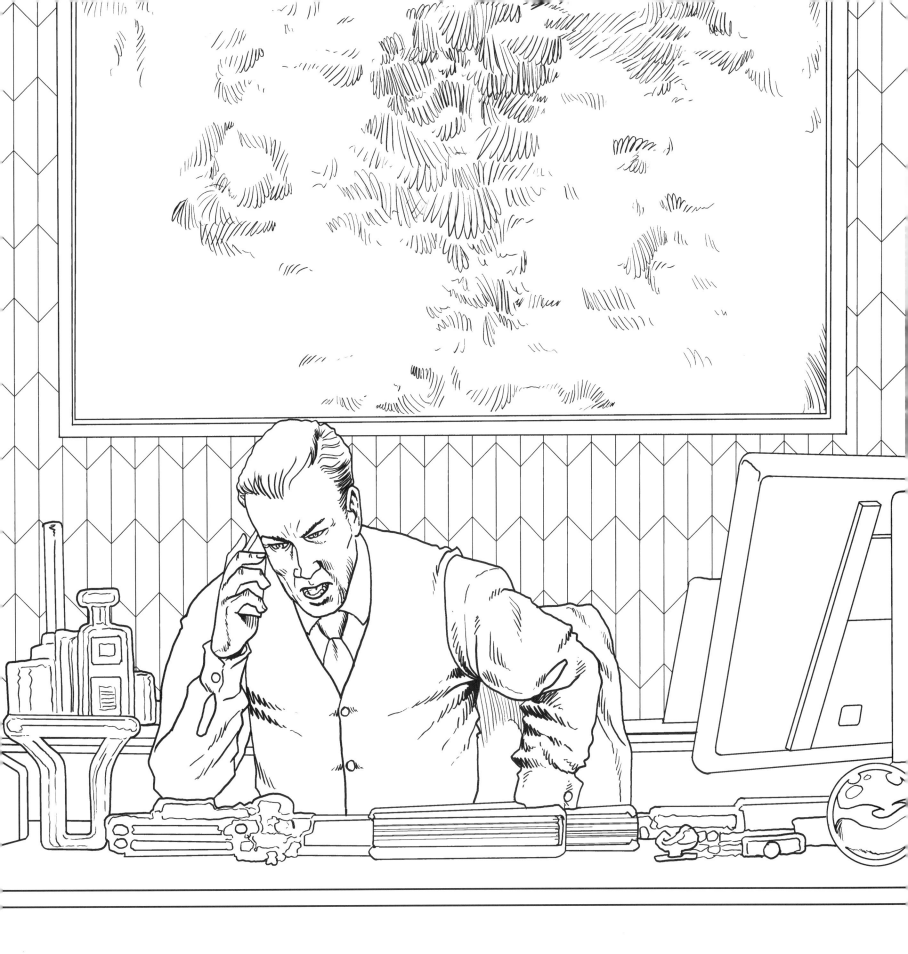

"UGGGHHHH."

-OWEN

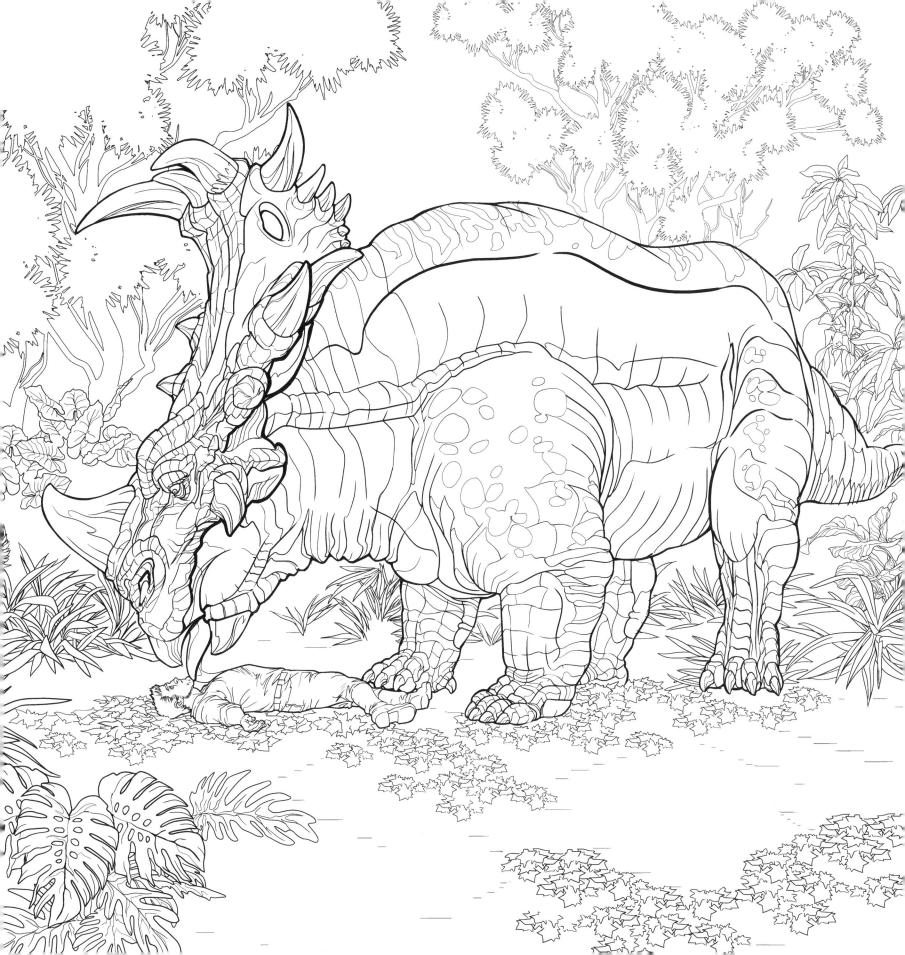

"UGGGH. UHHH."
          —OWEN

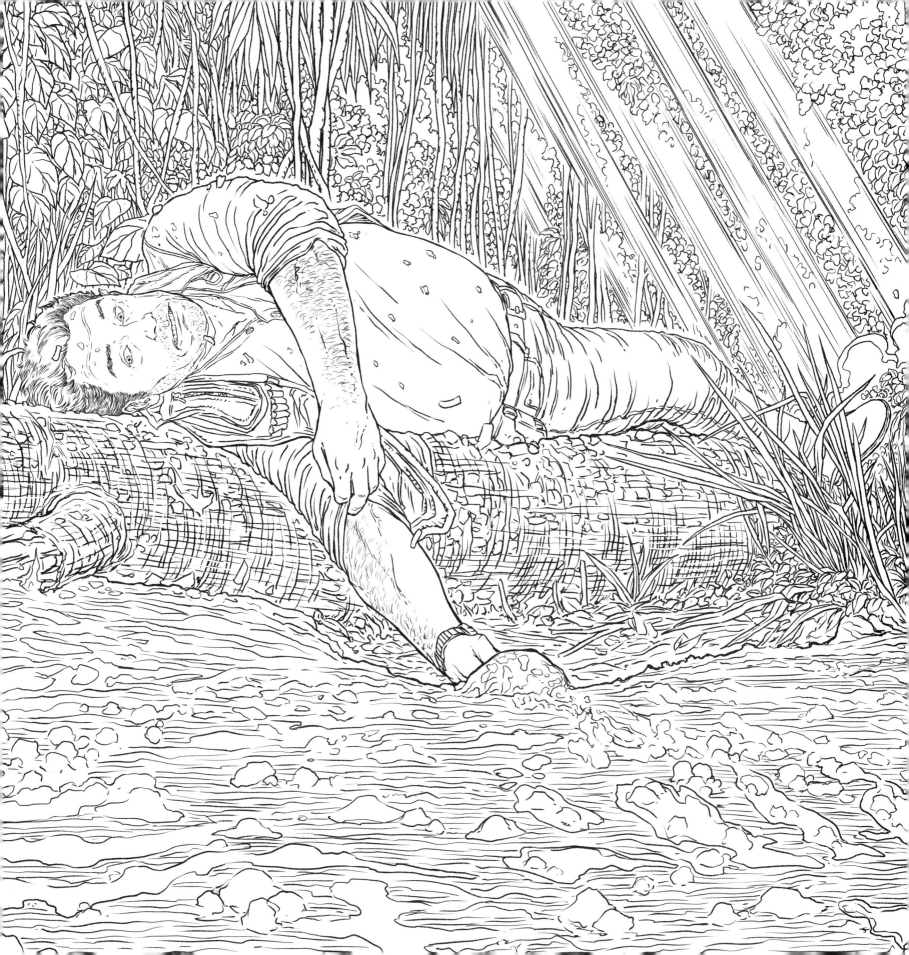

"SEE? IT'S NOT A *T. REX.*"

—CLAIRE

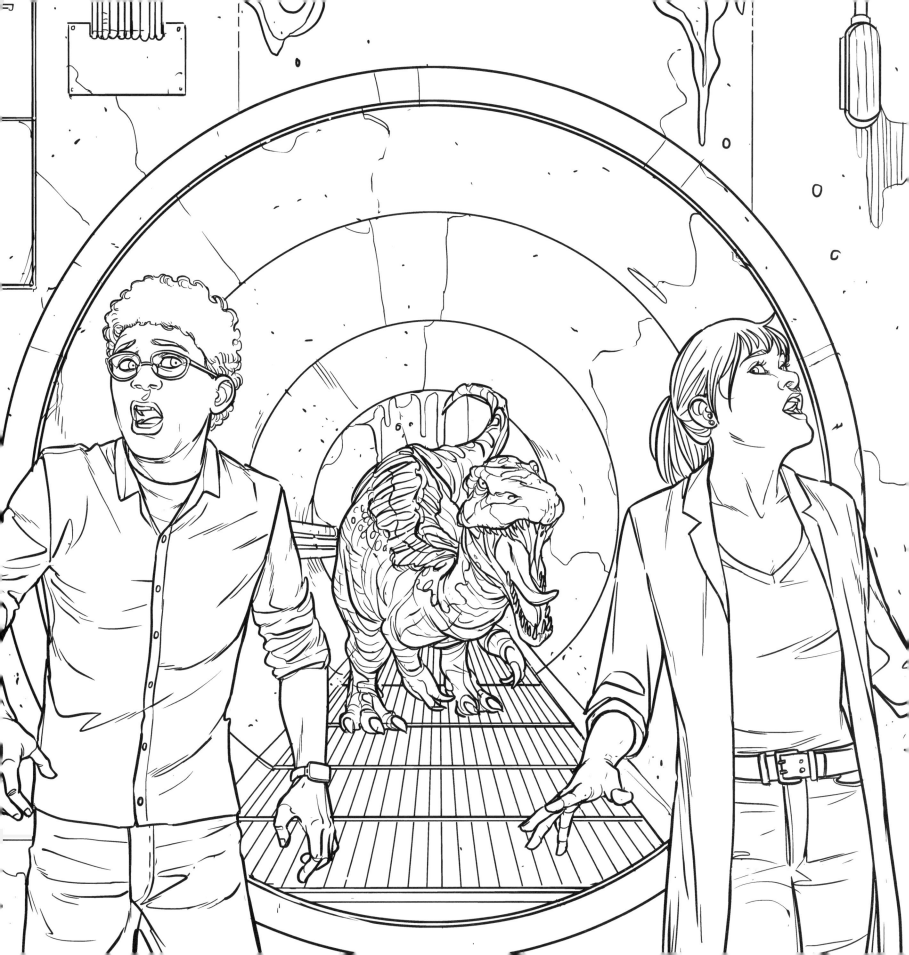

"RUN!"

    -OWEN

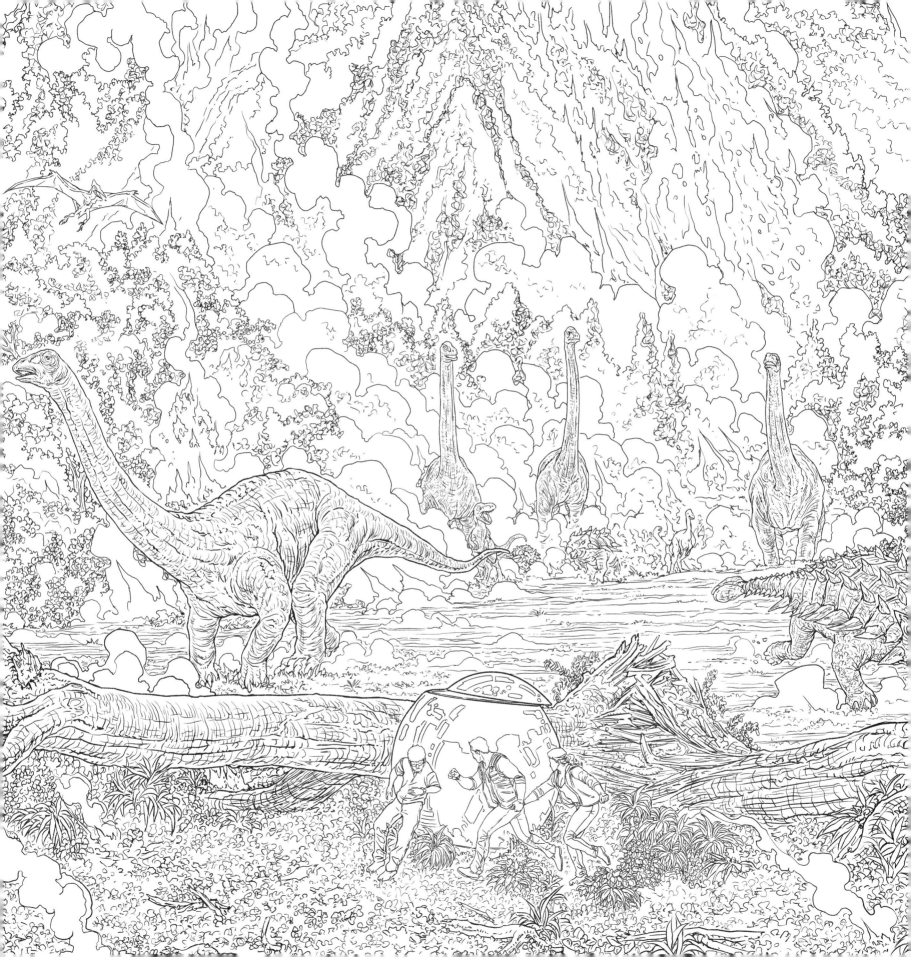

"RAAAWWWWRRRR!"

-T. REX

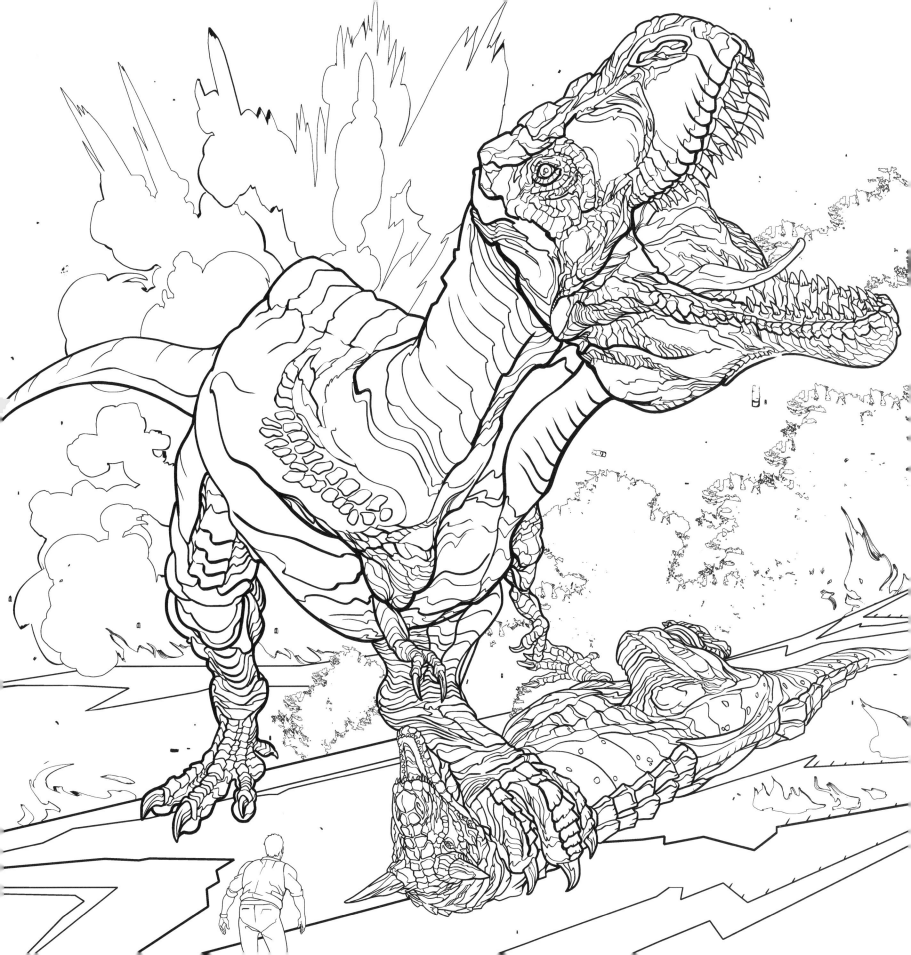

"OWEN!"

-CLAIRE

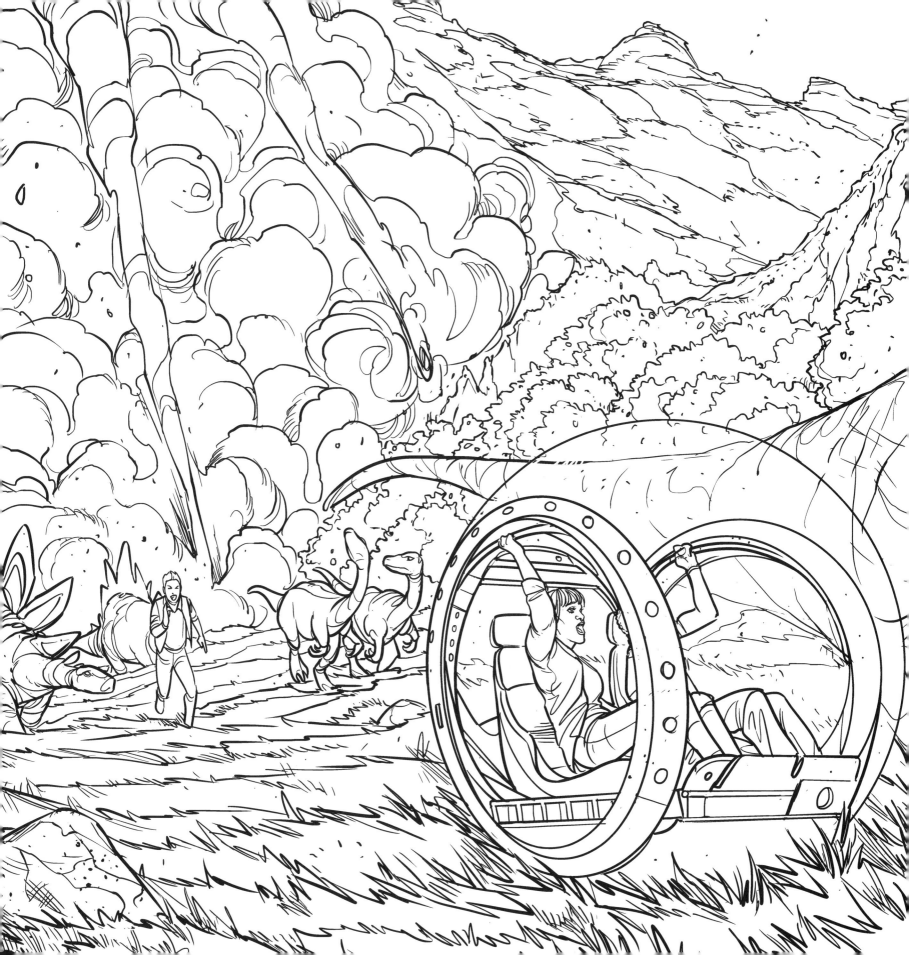

"CLAIRE. WE'RE GONNA SINK! WATER'S LEAKING."

-FRANKLIN

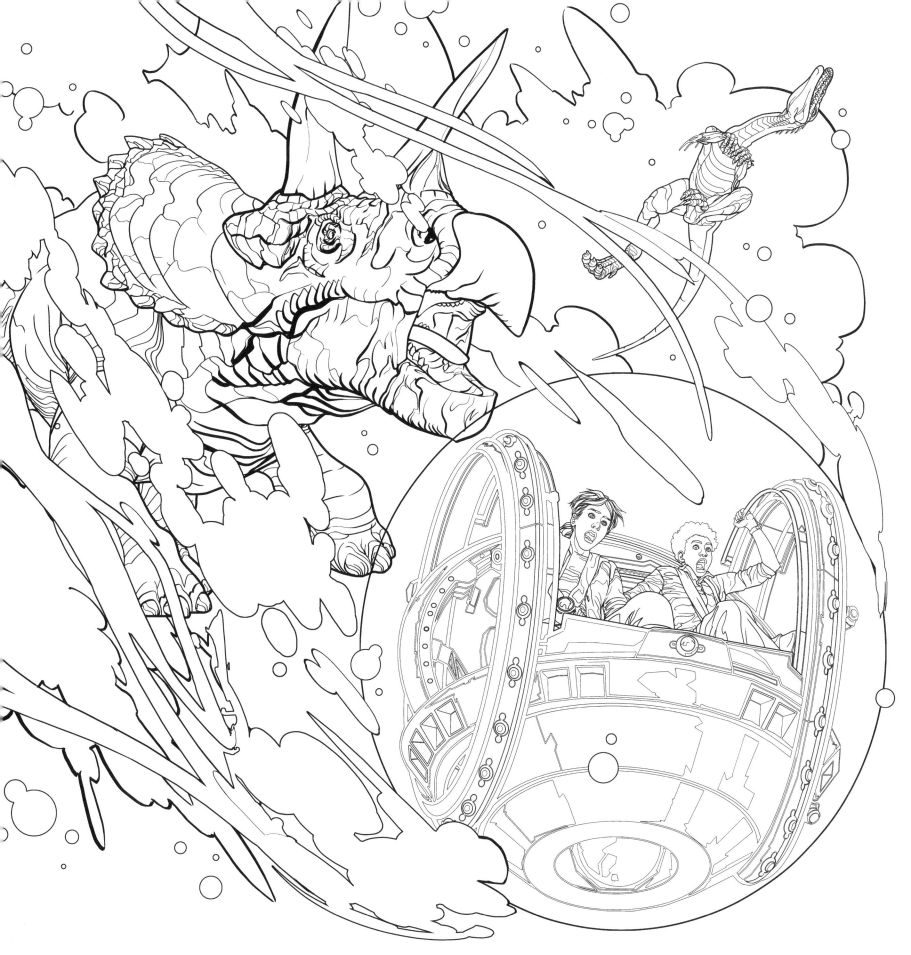

"IT WAS A LIE. IT WAS ALL A LIE!"

-CLAIRE

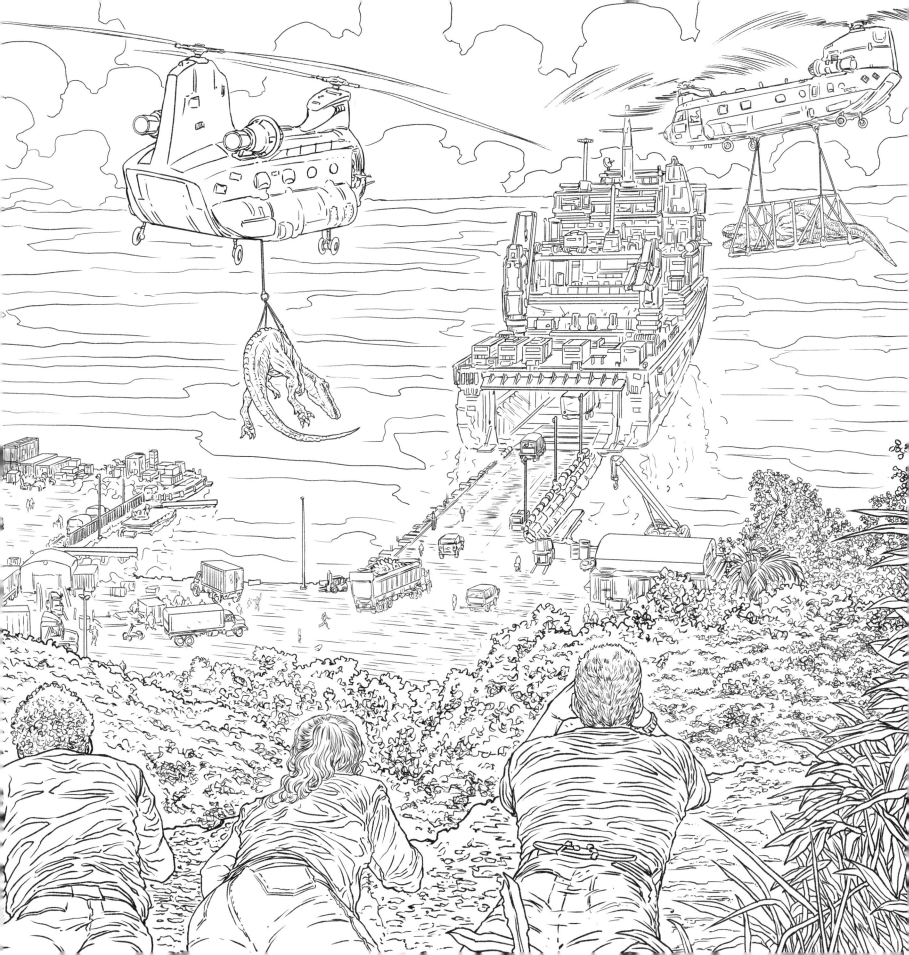

"WE NEED TO GET ON THAT BOAT!"

-OWEN

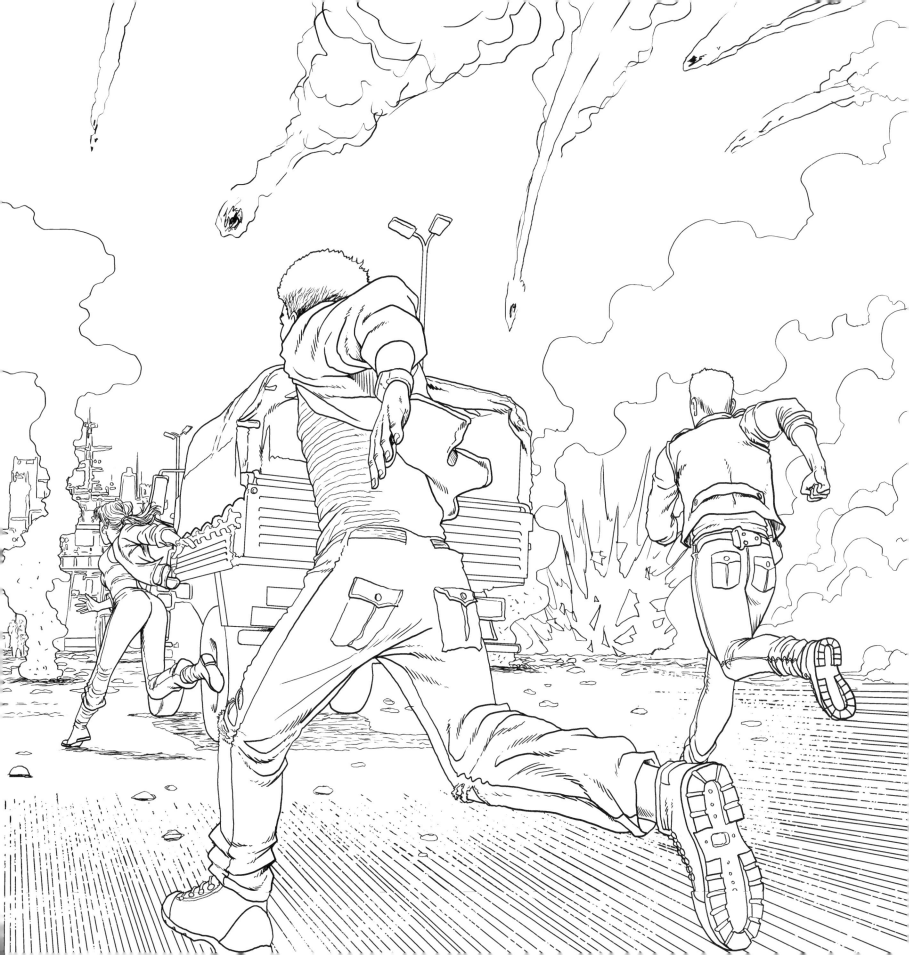

"BWWWAAHOOOMMMM."

-BRACHIOSAURUS

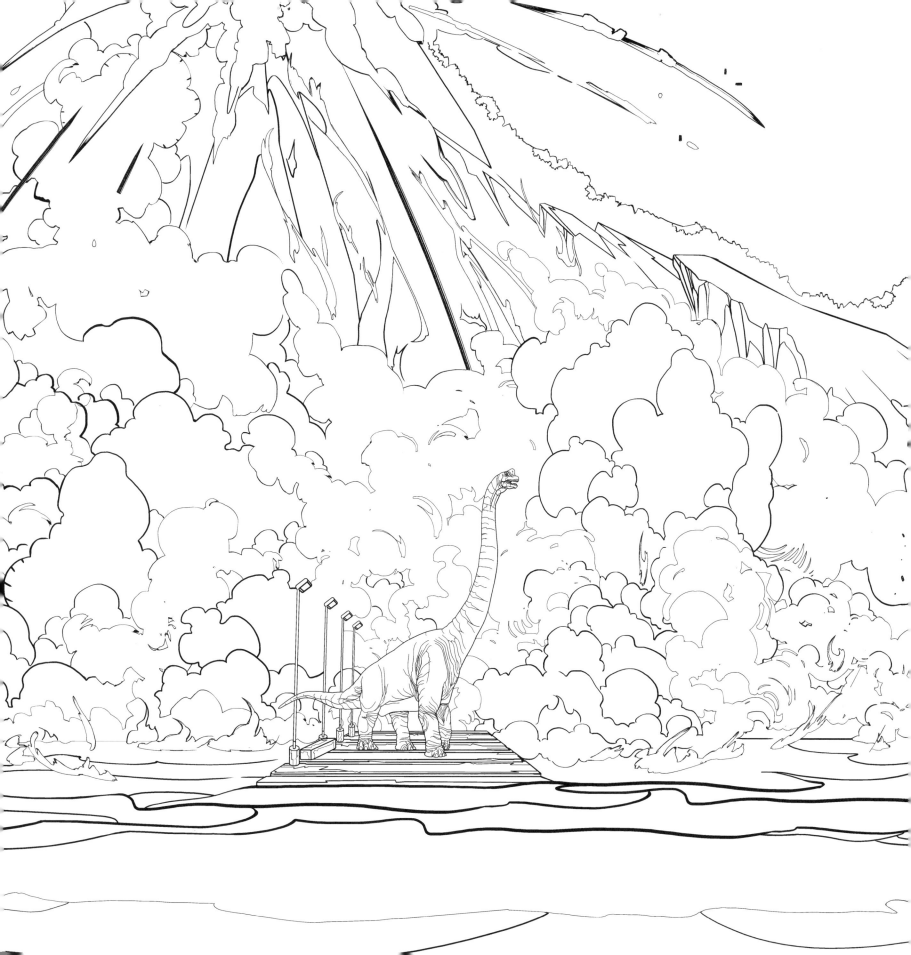

"OUR GENETICISTS HAVE CREATED A DIRECT DESCENDANT OF HENRY WU'S MASTERPIECE. THE ANIMAL THAT TOOK DOWN JURASSIC WORLD."

−ELI

"I CAN'T TAKE THE BULLET OUT WITHOUT A TRANSFUSION FROM ANOTHER ANIMAL. WHICH ONE OF YOU KNOWS HOW TO FIND A VEIN?"

-ZIA

"GOOD JOB. YOU'RE MAKING THIS LOOK TOTALLY NORMAL."

-OWEN

"BLUE'S DISPLAYING LEVELS OF INTEREST, CONCERN, HYPERINTELLIGENCE, AND COGNITIVE BONDING. BLUE IS THE KEY. YOU HAVE BLUE, YOU GET THESE RAPTORS TO DO ANYTHING."

-OWEN

"IT NEEDS A MOTHER! BLUE'S DNA WILL BE PART OF THE NEXT *INDORAPTOR'S* MAKEUP. SO, IT WILL BE GENETICALLY CODED TO RECOGNIZE HER AUTHORITY AND ASSUME HER TRAITS: EMPATHY, OBEDIENCE. EVERYTHING THE PROTOTYPE YOU HAVE NOW IS MISSING!"

–DR. HENRY WU

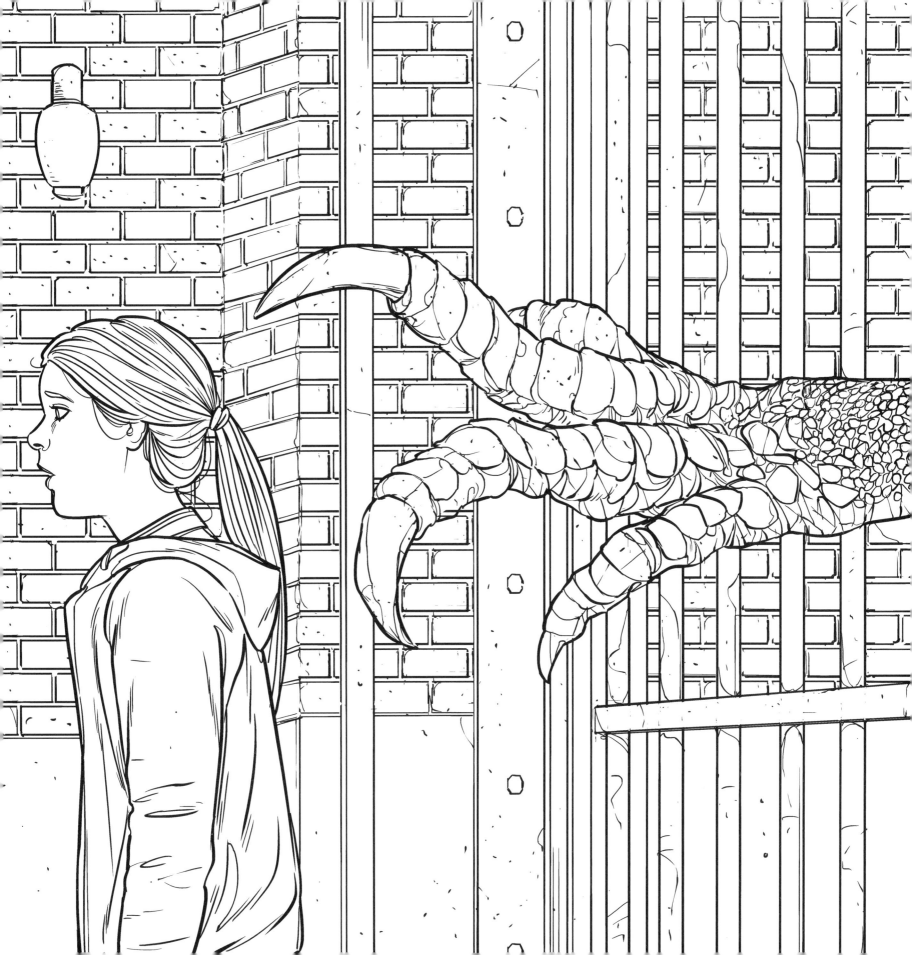

"YOU SHOULD HAVE STAYED ON THE ISLAND. BETTER ODDS."

                                                        -WHEATLEY

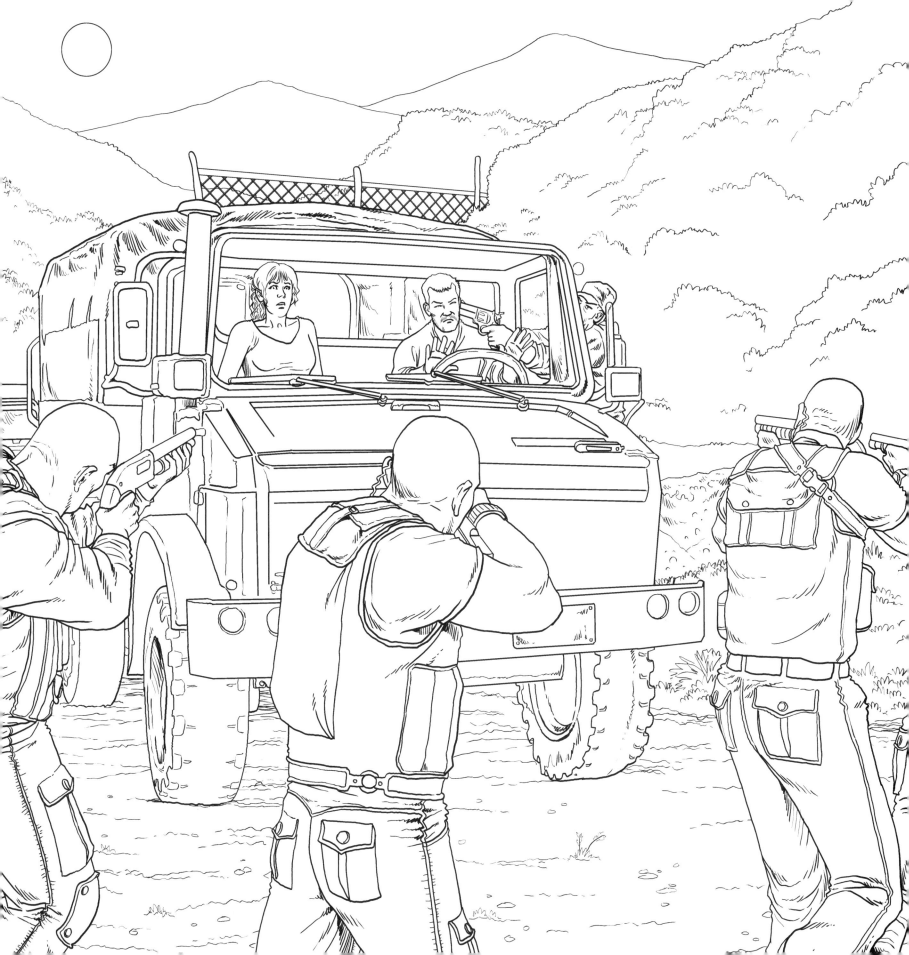

"WELCOME, LADIES AND GENTLEMEN, TO THIS EXTRAORDINARY EVENING. LET'S DIVE RIGHT IN WITH LOT NUMBER ONE. THE *AKLYOSAURUS*."

—GUNNAR EVERSOL

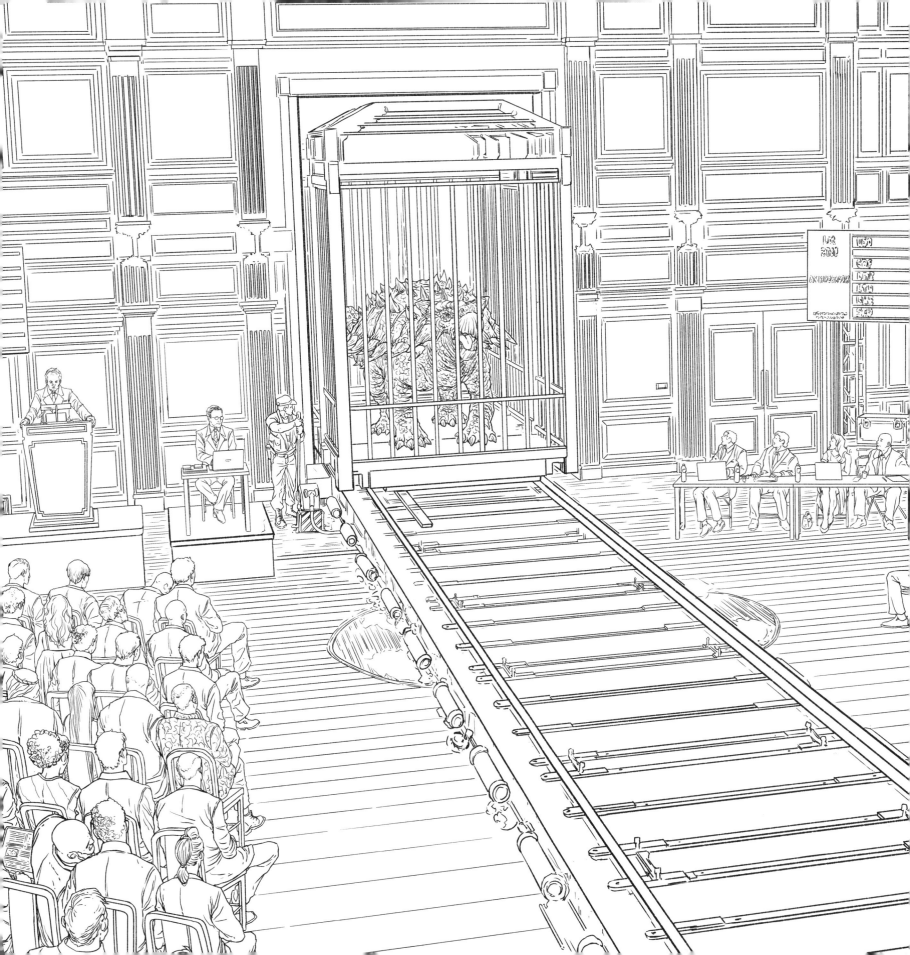

*WHISTLES*

"WHAT ARE YOU DOING?"

"ESCAPING."

"YOU SURE ABOUT THIS?"

"NOPE." *WHISTLES*

-OWEN AND CLAIRE

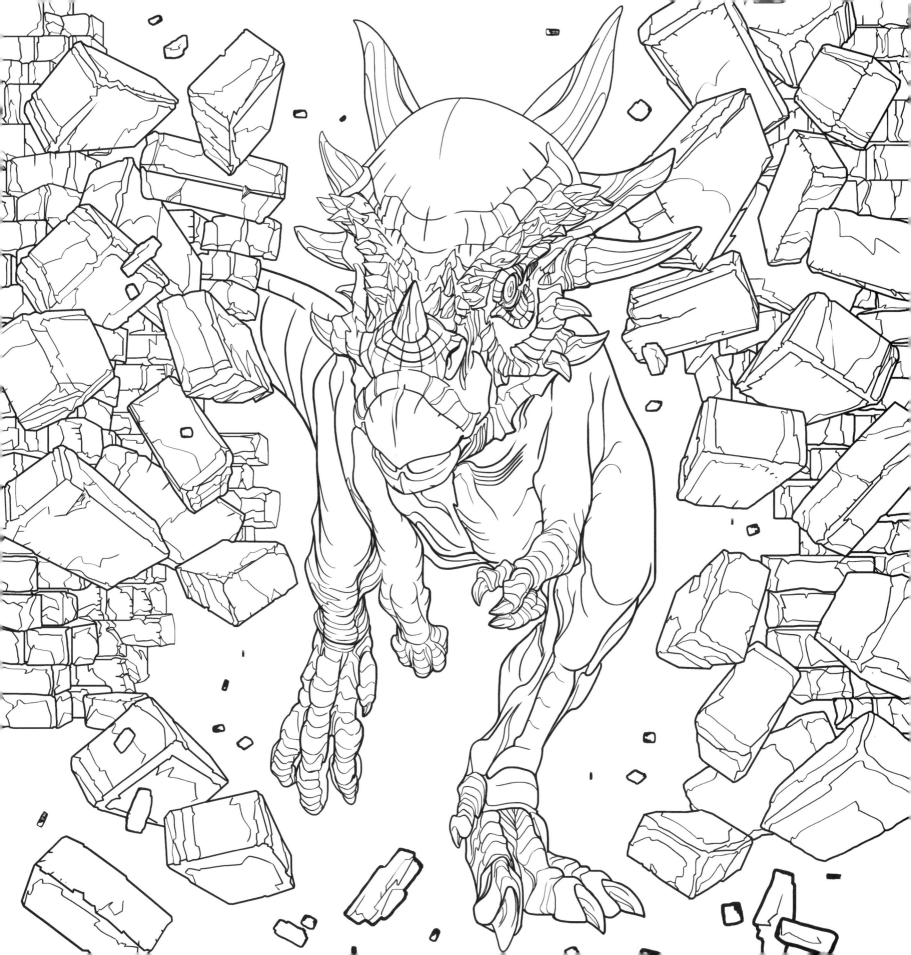

"WE CALL IT THE *INDORAPTOR.* THE
PERFECT WEAPON FOR THE MODERN AGE."

-GUNNAR EVERSOL

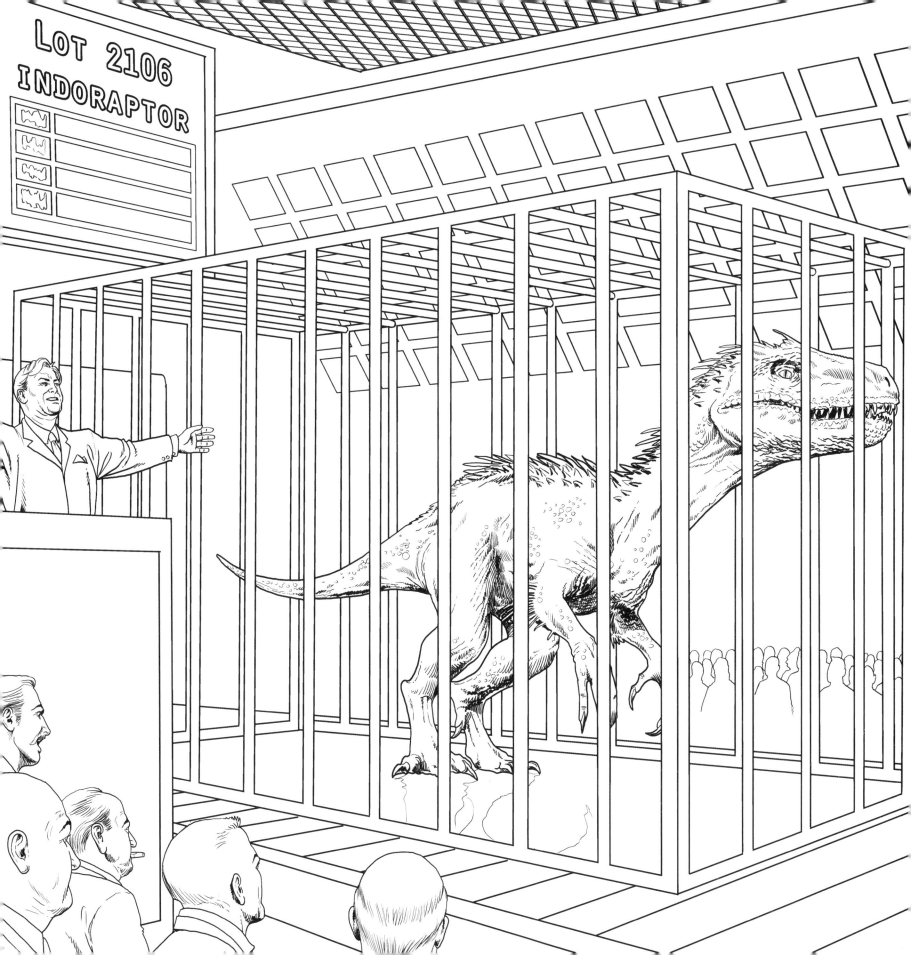

"HEY, BUDDY. YOU THINKING WHAT I'M THINKING?"

-OWEN

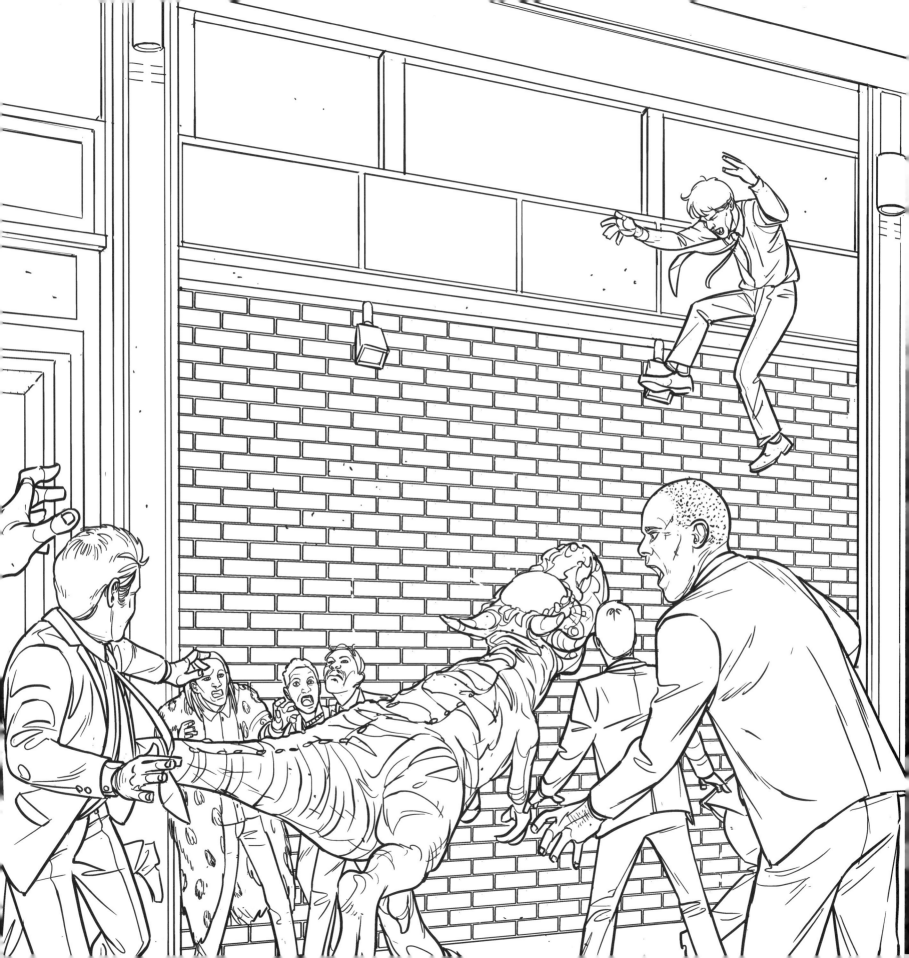

"LOOK AT YOU. YOU'RE SOME KIND OF HOT ROD. WITH REALLY PRETTY TEETH. THIS WILL MAKE A PERFECT CENTERPIECE FOR MY NECKLACE."

-WHEATLEY

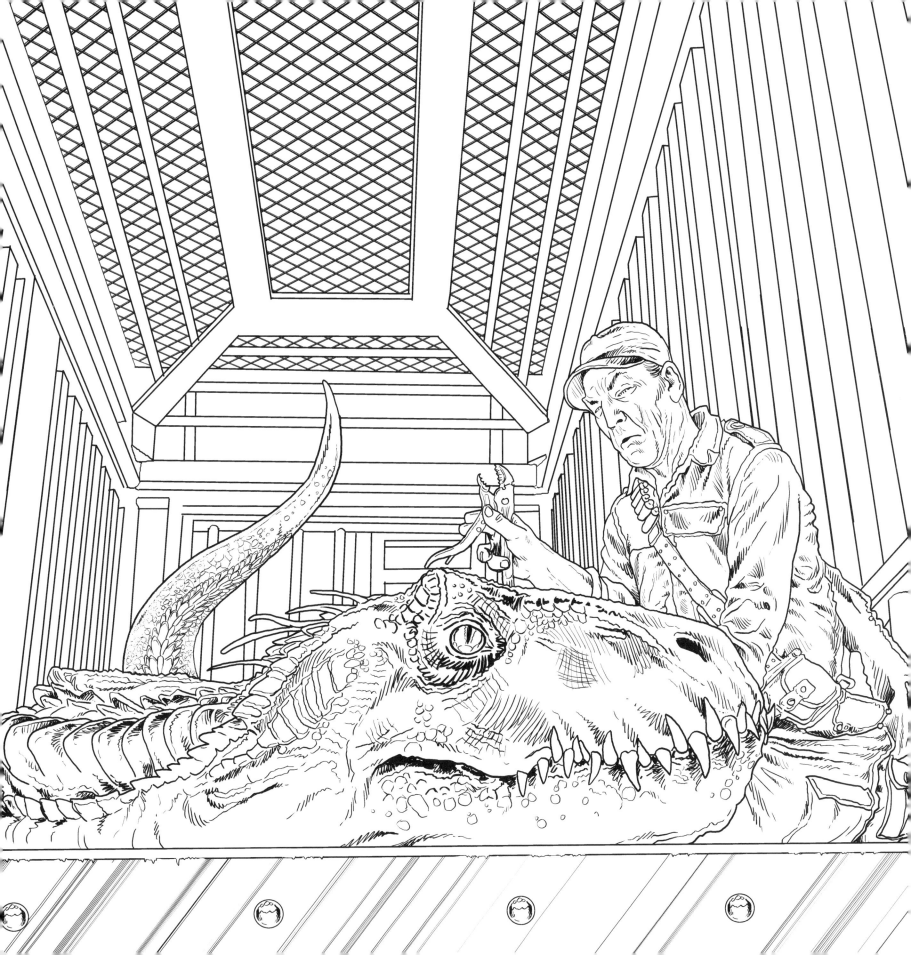

"RUN!"

-ZIA

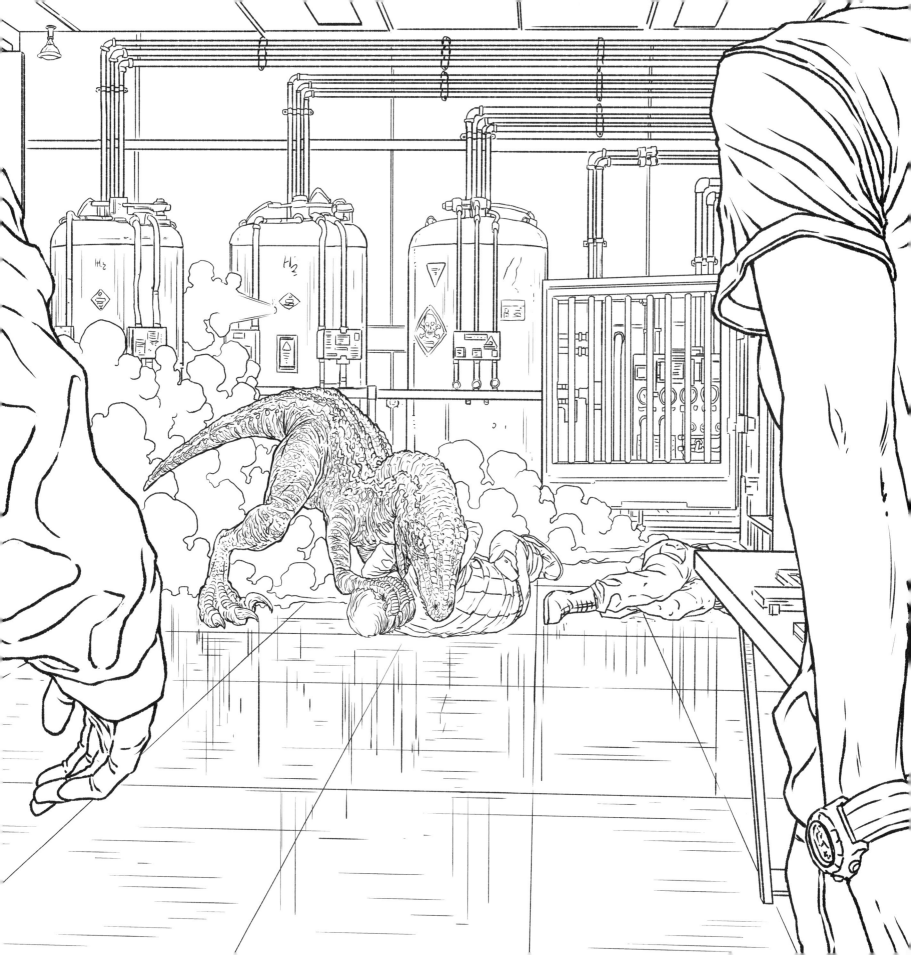

"GO, GO, GO!"

-CLAIRE

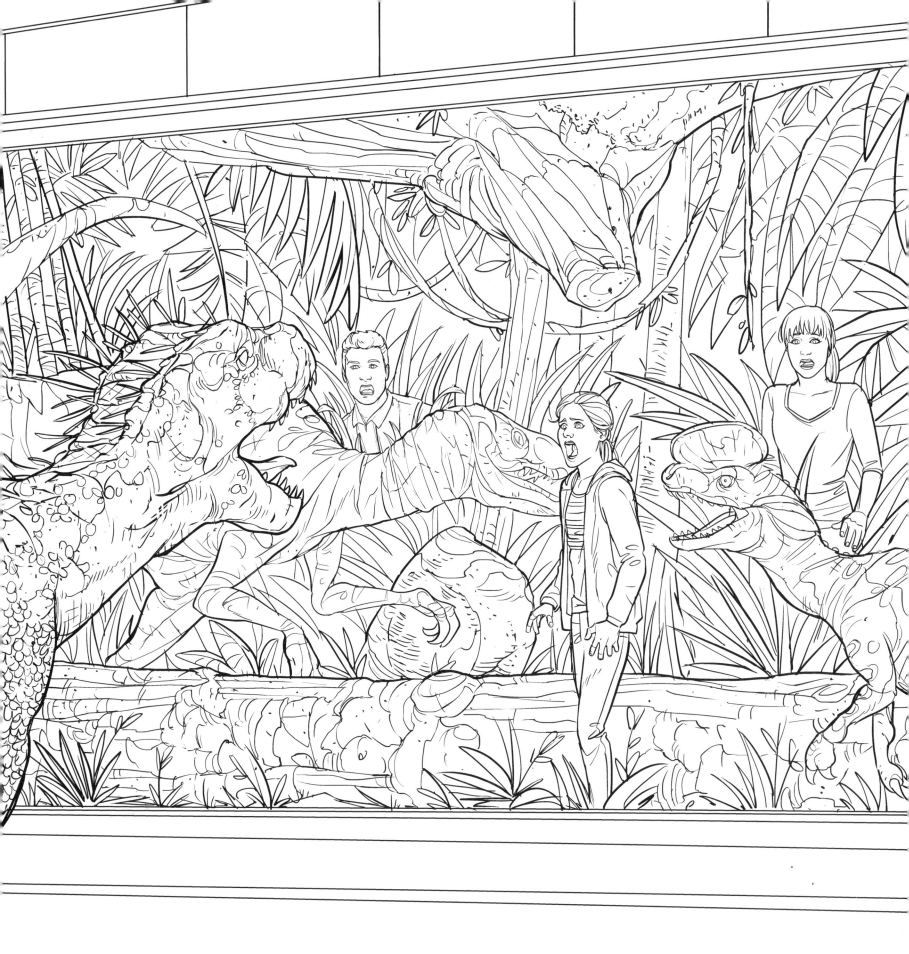

"YOU HAVE TO GO FIND HER."

-CLAIRE

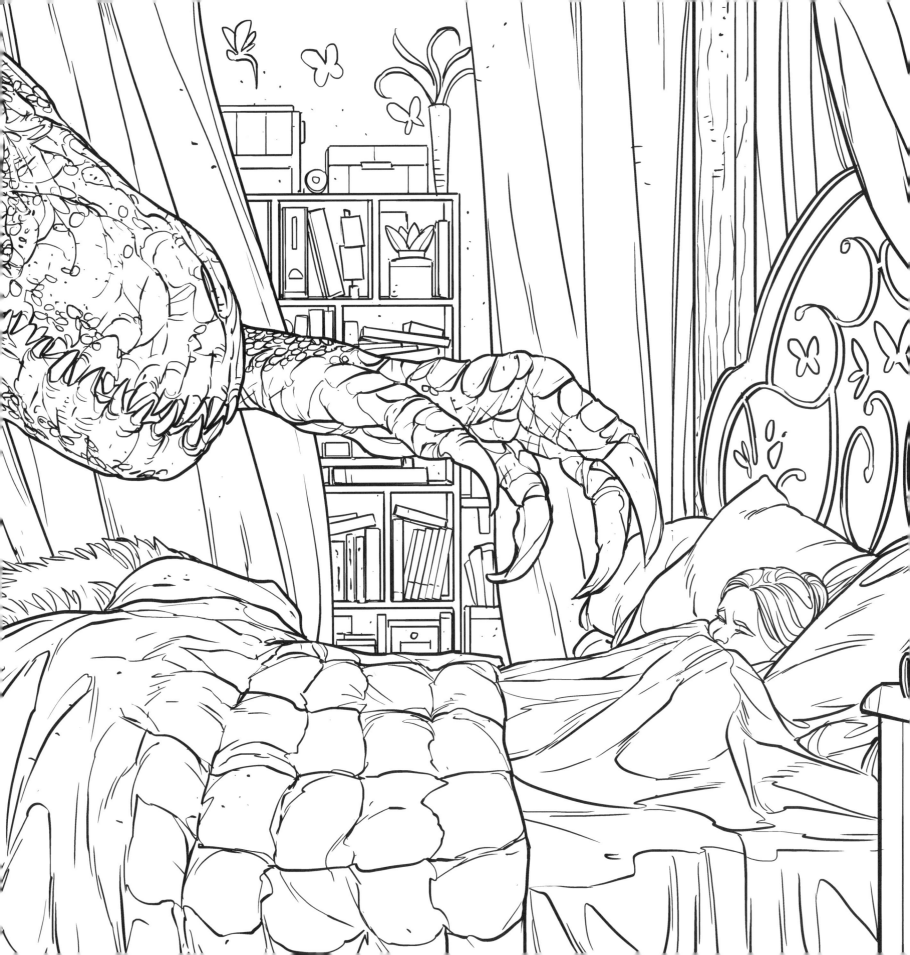

"FOLLOW ME. I KNOW A WAY ON THE OTHER SIDE."

-MAISIE

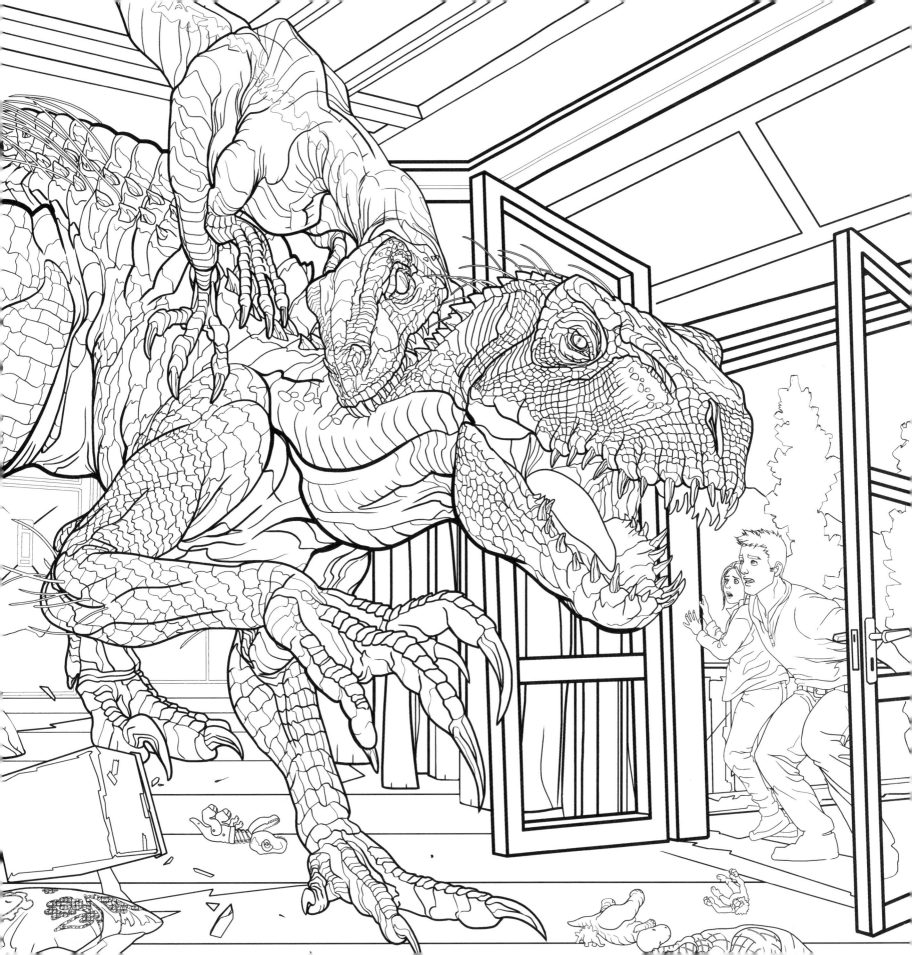

"COME ON!"

-CLAIRE

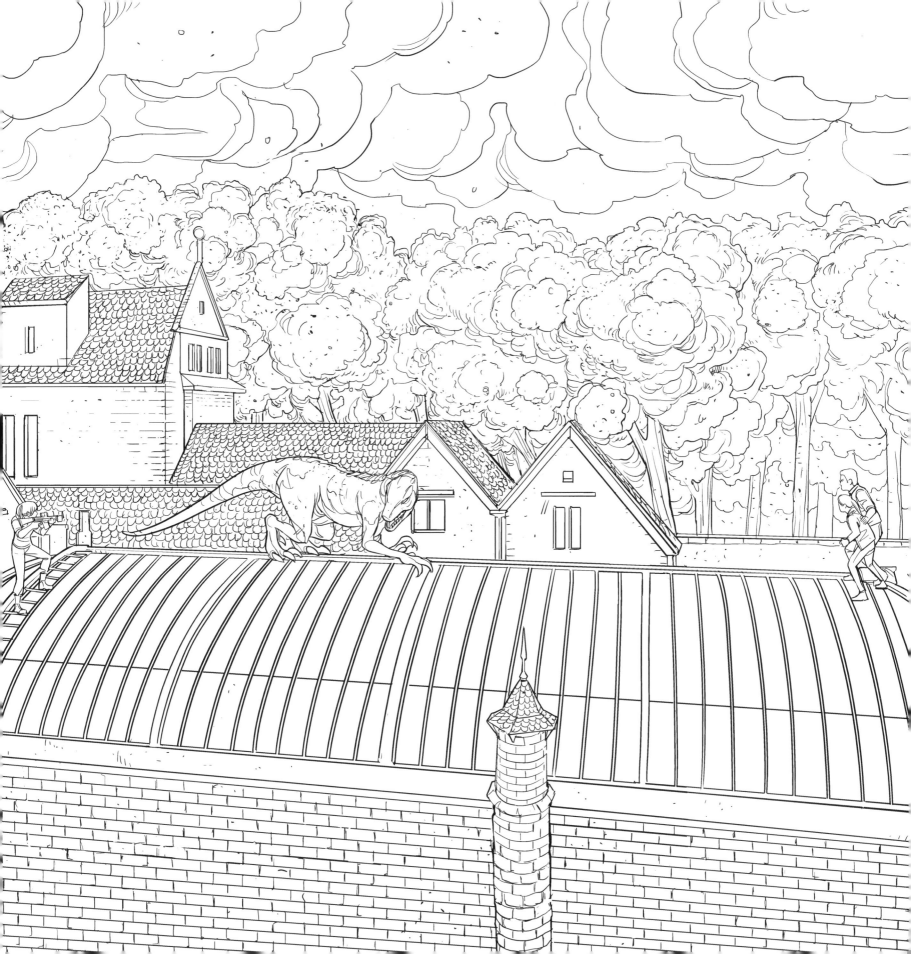

"SCREEEECCCCHHHH!!!"

-BLUE

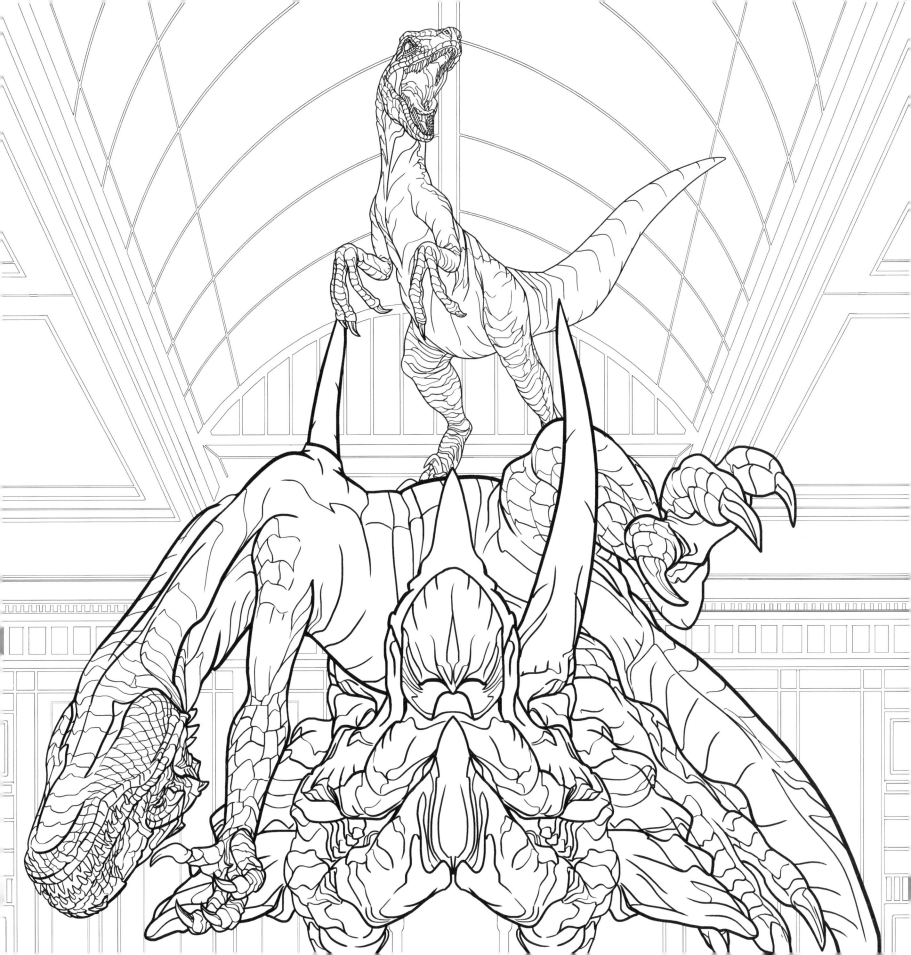

"I HAD TO. THEY'RE ALIVE. LIKE ME."

-MAISIE

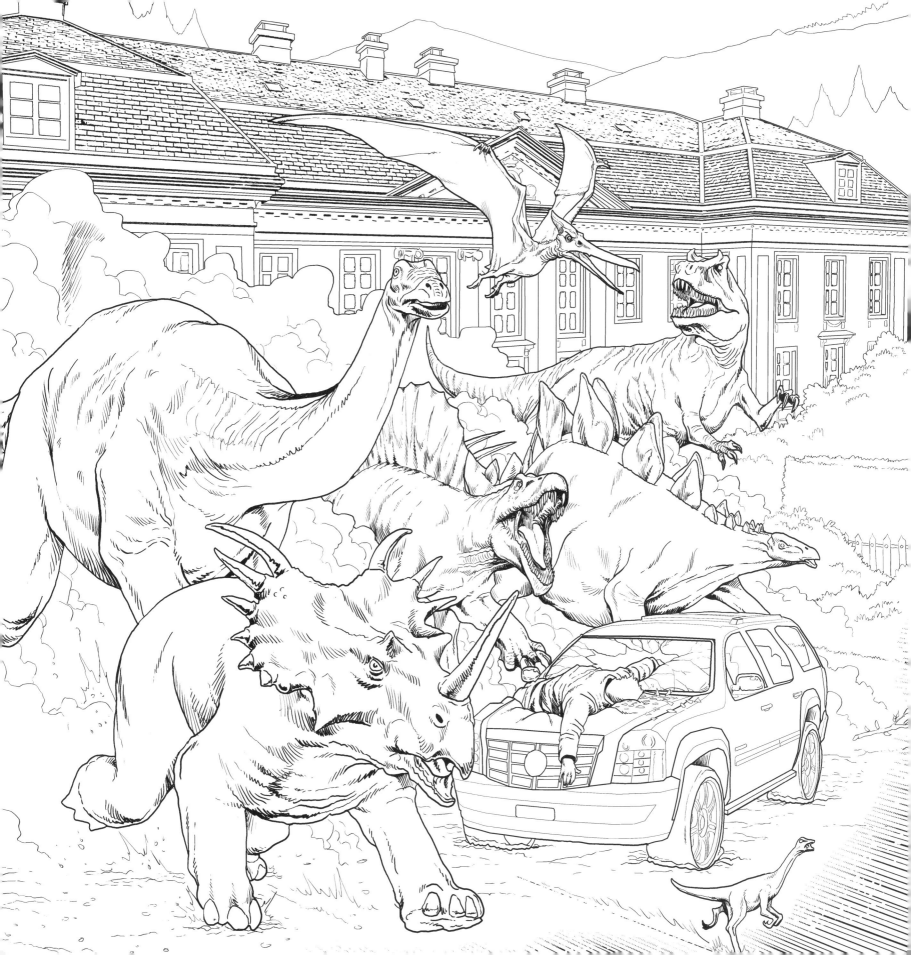

"AAAAHHHHHH!"

-ELI

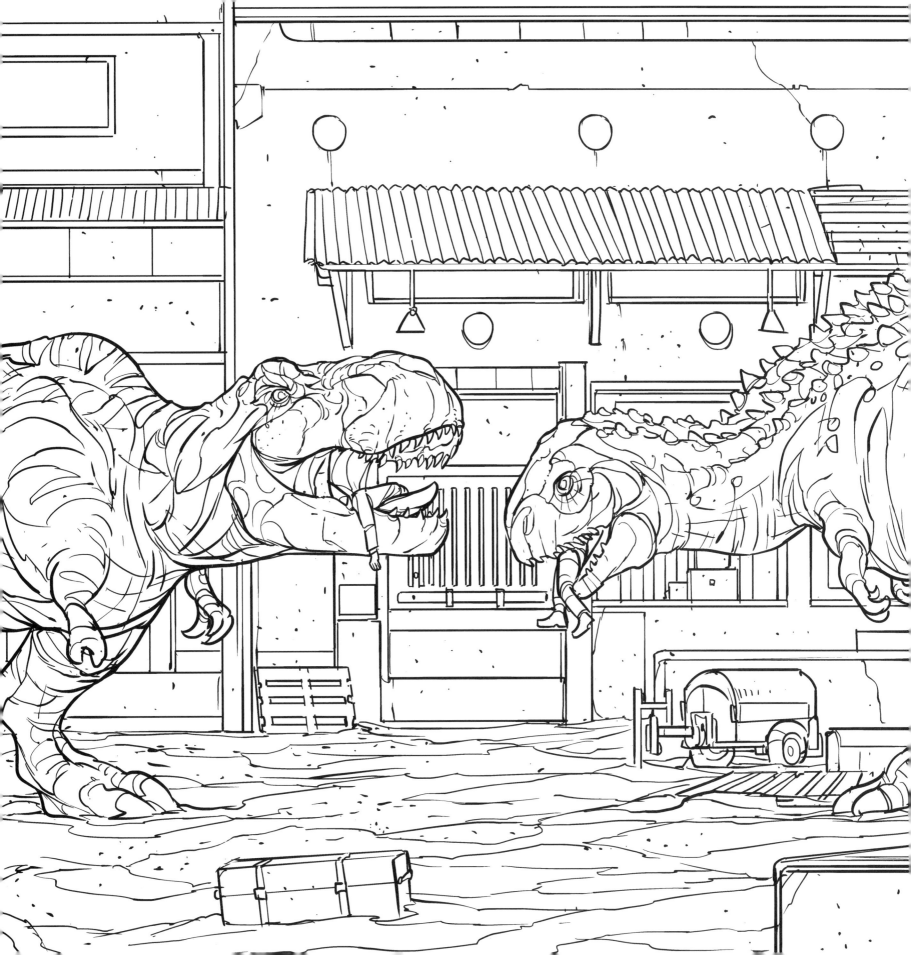

"BLUE, COME WITH ME. WE'LL TAKE
YOU SOME PLACE SAFE, OKAY?"

-OWEN

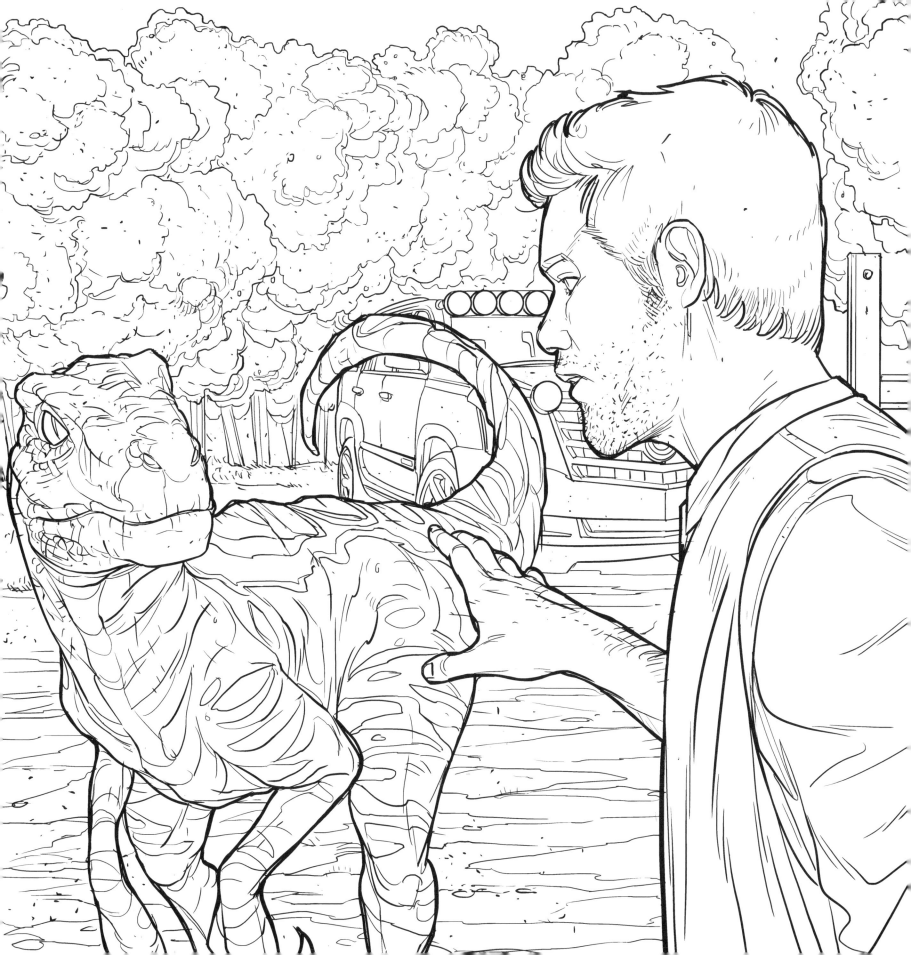

"WELCOME TO JURASSIC WORLD."

-DR. IAN MALCOLM

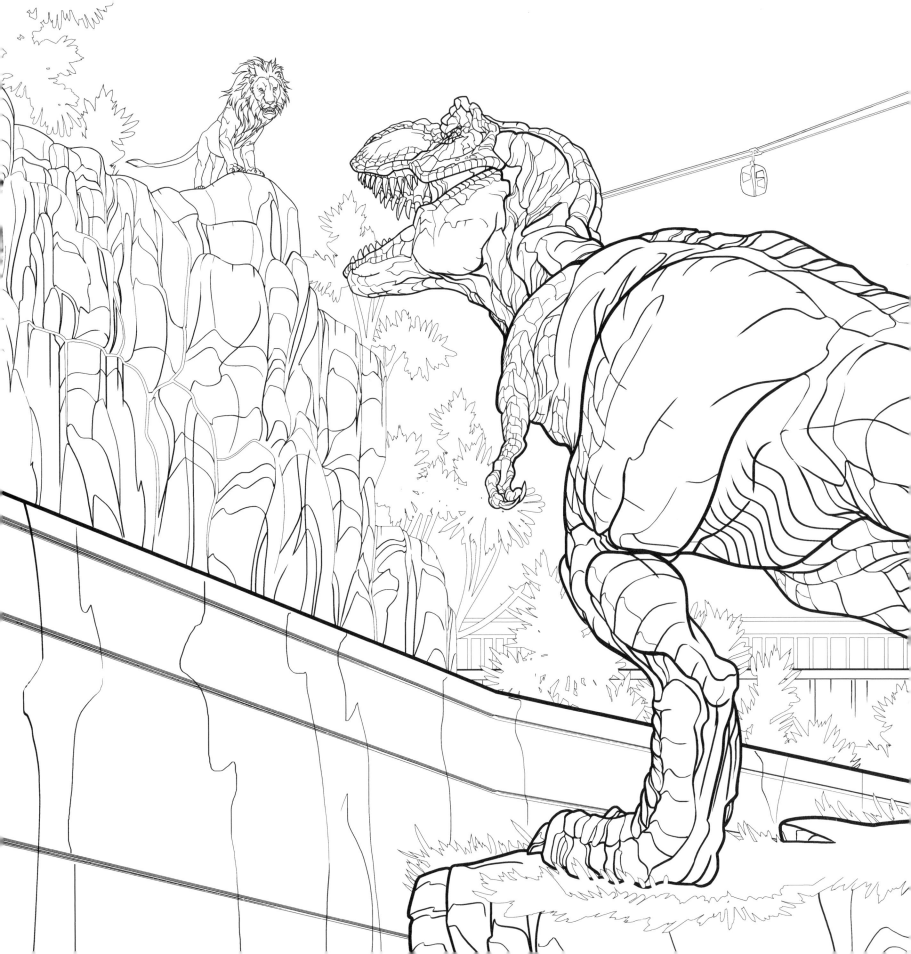

# ABOUT THE ILLUSTRATORS

## CRIS BOLSON

Born in 1972 in Belo Horizonte, this Brazilian illustrator and comic book artist kicked off his career in independent comics, both in Brazil and abroad. He also worked as an illustrator for advertising and taught drawing and visual storytelling at the Casa dos Quadrinhos Art School. He was the penciller behind the graphic novel *Hercules: The Knives of Kush* and inked for a Marvel special issue *AAFES #6*. His list of work includes titles such as *Battlestar Galactica Season Zero*, *Red Sonja Deluge*, *Danger Girl and the Army of Darkness*, and *Damsels in Distress* for Dynamite Entertainment. Recently, he worked on the comic books *Doctor Who: The Ninth Doctor* and *Doctor Who: The Lost Dimension Alpha* for Titan Comics.
Instagram: @cris_bolson

## MARC BORSTEL

Marc's career began in 2004 when he worked for the American indie publisher Cinemacomics on miniseries such as *The Last Warring Angel* (2004), *Zero Hunters* (2005), and *Misadventures of Clark and Jefferson* (2007-2009) as a penciller and colorist. In 2009, he worked on the graphic novel *The Outer Space Men* for OSM LCC as a colorist and then began collaborations with Ape Entertainment as a penciller and colorist in *Dream Reavers* (2010), *TechnoMancer* (2011), and *Flee* (2011). Since then, Marc has collaborated on projects like *Lady Death Apocalypse* for Boundless, *Dago* for the Italian publisher Aurea Editoriale, *Banda de Orcos* for the Argentinean publisher Editorial Pictus, and *Weapon X* for Marvel. He is currently working on the graphic novel *Invisible Empire* for Insight Studios, and *Grant Morrison's 18 Days/Karna* for Graphic India.
Website: MarcsGallery.BlogSpot.com.ar

## EDUARDO FRANCISCO

Eduardo's career began in 1998 when he was part of a group of young artists who gathered in a library to socialize and meet editors and professional artists who visited the site to give lectures. Now, with works published in the Middle East, Brazil, England, and the United States, he has had the opportunity to work alongside great talents of the industry in titles such as *World of Flashpoint*, *Adventures of Superman*, *Turok: Son of Stone*, *Mass Effect*, *Conan: The Avenger*, *EVE: Valkyrie*, *Smite*, *Total War*, *Aliens: Defiance*, and numerous other illustrations and concept art for various studios.

## ÁLVARO SARRASECA

Álvaro was born in Spain and started to draw comics in his country for many different magazines and publications in addition to his own graphic novel. He started working in the United States a few years ago as an illustrator for Dark Horse on *Dragon Age*, and as an artist and cover artist for Top Cow on *Witchblade*, Dynamite on *Turok*, *Sovereigns*, and *Killer Instinct*, and Aftershock on *Lost City Explorers*.
Website: asming.deviantart.com | Twitter: @alvaroming

# ADD TO YOUR COLLECTION WITH THE OFFICIAL *JURASSIC PARK* AND *JURASSIC WORLD* COLORING BOOKS!

## AVAILABLE NOW FROM DARK HORSE BOOKS!

**JURASSIC PARK COLORING BOOK**
ISBN 978-1-50670-974-1
$14.99 US | $19.99 CAN

**JURASSIC WORLD COLORING BOOK**
ISBN 978-1-50671-106-5
$14.99 US | $19.99 CAN